MW00770577

Athena and Eden
The Hidden Meaning of the Parthenon's East Façade

Robert Bowie Johnson, Jr.

SOLVING LIGHT BOOKS

©2002 Robert Bowie Johnson, Jr.
Solving Light Books
727 Mount Alban Drive
Annapolis, Maryland 21401

ISBN 0-9705438-1-6

All rights reserved. No part of this publication may be reproduced in any form, electronic or mechanical, without prior permission of the publisher in writing.

Cover Illustrations:

Eve by Albrecht Dürer, oil on panel, 1507, Museo del Prado, Madrid.

Athena Parthenos, full-size reproduction in the Nashville Parthenon by Alan LeQuire (Parthenon.org).

Parthenon photograph, east façade from the East, courtesy of the Department of Archaeology, Boston University, Saul S. Weinberg Collection (Perseus Library).

The drawing of the east pediment, repeated in portions throughout, is that of Kristian Jeppesen from the 1982 Parthenon Kongress in Basel, Switzerland, with the author's identities of the figures overprinted.

All Scripture passages, unless otherwise noted, are from the Concordant Translation, Concordant Publishing Concern, Santa Clarita, CA (Concordant.org). Information on the correct translation of Genesis 1:2 in chapter 7 about Nyx is taken directly from the writings of A. E. Knoch, co-founder of the Concordant Publishing Concern.

Material from the Perseus Library, noted in the photo credits, is copyrighted by the Corporation for Public Broadcasting and the President and Fellows of Harvard College.

The author is very thankful for the immense contributions to our knowledge of the ancient Greek world from the following scholars: Bernard Ashmole, Sir John Boardman, T. H. Carpenter, David Castriota, Peter Connolly, B. F. Cook, Gregory Crane (Editor-in-Chief of the Perseus Project) and all of his associates, Hazel Dodge, Richard G. Geldard, Peter Green, Evelyn B. Harrison, Jane Ellen Harrison, Kristian K. Jeppesen, Carl Kerenyi, Mary R. Lefkowitz, Jenifer Neils, Olga Palagia, Carlos Parada, J. J. Pollit, Noel Robertson, H. A. Shapiro, Erika Simon, Edward Tripp, Nicholas Yalouris, Froma I. Zeitlin, and many others, here unnamed.

Thanks to:
The Perseus Library.
Anne Arundel Community College Library staff.

Thanks also to:
Peter Lord, Peter Perhonis, Peggy Griggs, Jack Thomasson, Mark Wadsworth, Frank Bonarrigo, Richard Burt, Don MacMurray, Robert Alcorn, Michael Thompson, and Richard Elms.

And special thanks to Bernie Ruck.

For Nancy Lee

Contents

Preface and Introduction

Preface 7

Introduction 9

Part I: Reconstructing the East Pediment

Chapter 1: The Pieces of the Puzzle 13

Chapter 2: The Central Figures—Zeus, Athena, Hephaistos,
and Hera 21

Part II: The Identity of the Central Figures

Chapter 3: Athena—The Deified Eve 29

Chapter 4: Zeus—The Transfigured Serpent 39

Chapter 5: Hera—The Primal Eve 53

Chapter 6: Hephaistos—The Deified Cain 69

**Part III: The Background of Athena's Birth—The Right Side of
the Pediment**

Chapter 7: Nyx—The Darkness out of Which Arose Paradise 77

Chapter 8: The Hesperides—A Picture of Paradise 85

Contents

Chapter 9: Atlas Pushes away the Heavens, and with Them,
 the God of the Heavens 93

Chapter 10: Hermes, the Deified Cush, Connects Eden with
 the Rebirth of the Serpent's Eve 99

**Part IV: The Power and Promise of Athena's Birth—
 The Left Side of the Pediment**

Chapter 11: Helios—The Rising Sun Heralds the Birth of
 Athena and the New Greek Age 105

Chapter 12: The Immortal Herakles—Nimrod Transplanted to
 Greek Soil 109

Chapter 13: The Three Fates—Death Turned Back by the
 Immortal Athena 125

Chapter 14: Nike Amplifies the Victory of Zeus and Athena 129

Part V: Summary and Epilogue

Chapter 15: A Summary of the East Pediment 135

Epilogue 147

Art and Image Credits 149

Bibliography 156

Preface

[Greek civilization at last almost welcomed] those conquering Romans through whom dying Greece would bequeath to Europe her sciences, her philosophies, her letters, and her arts as the living cultural basis of our modern world.

Will Durant, *The Life of Greece*

Athens was the shining star of the ancient world, dominating almost every field of human endeavor.

Peter Connolly, *The Ancient City*

Athens is the original home of Western civilization.

John M. Camp, *The Athenian Agora*

Learned men have written great books about the building that rose before us; mighty battles of logic or opinion have been fought over almost every detail; each of its marble blocks has been measured with a painstaking accuracy that would be ridiculous were it any other building than the Parthenon: but "all the Old World's culture culminated in Greece, all Greece in Athens, all Athens in its Akropolis, all the Akropolis in the Parthenon."

Eugene P. Andrews in 1896, from *The Parthenon*

One always has the sense in approaching the Akropolis of Athens of being in the company of all mankind. It is one of the universal places, where the collective mind and soul meet and gather to a point of perception. Even the most dull of heart have been transformed by this space.

R. G. Geldard, *The Traveler's Key to Ancient Greece*

Preface

[T]he Akropolis is certainly the focal point of any visit, and every archaeological tour inevitably starts from the Parthenon, the temple that symbolizes Greek architecture and, in its structure and ornamentation, represents the very essence of the spirit of Greek civilization.

Furio Durando, *Ancient Greece*

And I, in the trials of war where fighters burn for fame, will never endure the overthrow of Athens—all will praise her, victor city, pride of man.

Aeschylus, *Eumenides*

Our city is an education to Greece . . . Future ages will wonder at us, as the present age wonders at us now.

Perikles

But the more one contemplates the Greeks, who have played this enormous part in the forming of our own lives, the more one wants to find out how it all began.

Michael Grant, *The Rise of the Greeks*

We are now ever more cognizant that Classical Greece was not only a foundation of Western civilization, but also a bridge to prehistoric times.

Ellen D. Reeder, *Pandora*

Introduction

As we look to the basis of our essentially Greek civilization, we find the Parthenon at its focal point. This imposing Classical structure, built during the imperial apogee of our culture's youth, boasted more sculptural decoration than any other temple in Greek antiquity. And yet, for more than 2,000 years, the true meaning of these depictions has remained hidden beneath distracting myths and explanations which strain our credulity: the lame god Hephaistos cracks open the head of Zeus with his axe and out pops Athena (east pediment), Poseidon and Athena compete in a contest for control of Attika (west pediment), the gods fight the Giants (east metopes), Greeks fight Amazons (west metopes), Lapiths battle centaurs (south metopes), Greeks destroy Troy (north metopes), a great procession presents Athena with an embroidered cloak (the frieze). We don't understand what these things mean. How incongruous that this should be so! It is as if a vaunted oak with branches extending across the earth and up into the heavens should look down at the acorn and say, "I don't recognize you; I don't understand what you are."

Let me put it a different way. Charles Freeman, in his book *The Greek Achievement*, has written, "The Greeks provided the chromo-

somes of Western civilization." We know that the Parthenon stood at the very center of Classical Greek civilization, the basis of our own. We should comprehend, intuitively even, what the Parthenon is. And yet one of the great scholars of the ancient Greek world, John Boardman, has written "[T]he Parthenon and its sculptures are the most fully known, if least well understood, of all the monuments of classical antiquity that have survived." Where is the lost understanding, and how did we lose it?

My aim in this series is to provide that lost understanding. In this first book, *Athena and Eden*, we are going to learn the surprising identity of Athena and unlock the meaning of the sculptures which graced the east façade of her famous temple. The Greek myths tell us much but the key to their correct interpretations lies elsewhere. Of all places, we find it in the Scriptures, particularly the Book of Genesis. As we use this invaluable key to open the door of our Greek past, we shall enter into an inspiring new realm of knowledge. The simple secret is that the Book of Genesis and the Parthenon sculptures tell the same story from opposite viewpoints.

The Parthenon is not considered one of the seven wonders of the ancient world when, in fact, it should be rated as foremost among the great monuments of our past. Its goddess and its sculptures tell us where we—the human race—have come from and suggest in a most profound way where we are headed. For us, Athena's temple will seem very much like a time capsule, the contents of which we are at long last beginning to comprehend. Let's begin our exploration.

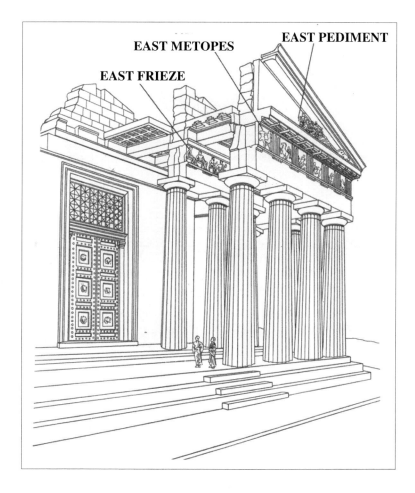

EAST FRIEZE

EAST METOPES

EAST PEDIMENT

Cutaway Drawing of the Parthenon from the East

Chapter 1
The Pieces of the Puzzle

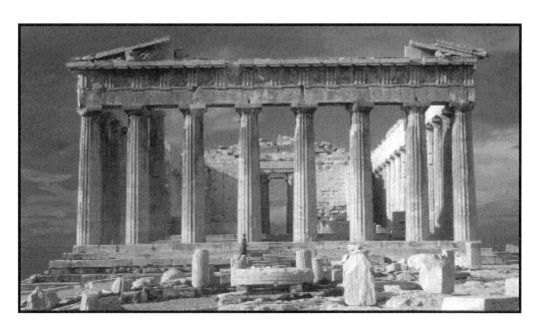

The east façade of the Parthenon as it looks today, disencumbered of all the statues. Almost the entire pediment is missing. Surviving sculptures from the left and right sides of the pediment in the British Museum and elsewhere preserve crucial images relating directly to the central scene. We know—from a single sentence written by the ancient travel writer Pausanias—that the central scene represented the birth of Athena.

A Brief History of the Parthenon and Its East Façade

Work began on the Parthenon in 447 BC under the political direction of Perikles, the artistic direction of Phidias, and the architectural direction of Iktinos and Kallikrates. The Greeks dedicated the temple nine years later in 438 BC when Phidias completed the interior gold and ivory statue of Athena Parthenos. Work continued until 432 BC when the sculptors finished their work on all the adorning figures.

Athena's temple remained in continuous use for about a thousand years until Christian officials, in the late fifth or early sixth century, converted it into a church, and removed the central figures of the east pediment. Many of the remaining sculptures undoubtedly suffered deliberate defacement at the hands of zealous believers.

In 1687, the Turks, besieged by the Venetians, used the Parthenon as a gunpowder magazine. On September 26th, the Parthenon took a direct hit from a Venetian shell, and the powder stored there exploded. The blast destroyed most of the interior walls of the temple (apart from the west end), and whole groups of columns on the north and south sides along with much sculpture. Damage to the east pediment was relatively minor. We know this because we have drawings attributed to an artist named Jacques Carrey who visited Athens with the French ambassador to the Turkish Court in 1674. His drawings show that the entire center of the east pediment was missing before the explosion of 1687.

In 1800, when the Akropolis of Athens was a Turkish fortress, the British Crown appointed Thomas Bruce, the seventh earl of Elgin, as its ambassador in Constantinople. From 1801 to 1810, Lord Elgin, largely through the bribery of Turkish officials, removed much sculpture from the Parthenon including almost all of what remained on the east pediment. He shipped it back to England and in 1816 sold his collection to the British Museum where it is on display today.

Since that time and continuing today, scholars have been trying to reconstruct the lost center of the pediment, and to accurately portray and identify the remaining figures. On the pages that follow we will examine the pieces of the puzzle that they, and we, have to work with.

The Pieces of the Puzzle—What We Have to Work With

The pieces of our puzzle, the clues available to help us solve the case of the missing east pediment and its meaning are basically these:

- The terse 2nd century AD description of the pediment by the travel writer Pausanias—by far the most important clue (see below).

- The Parthenon sculptures in the British Museum (the so-called Elgin Marbles).

- Sculptural fragments in the Akropolis Museum.

- The 1674 drawings of Jaques Carrey.

- Relevant painting, sculpture, and literature pre-dating the Parthenon, and therefore likely to have influenced the depictions on it.

- Relevant painting, sculpture, and literature post-dating the Parthenon and therefore likely to have been influenced by it.

- Technical evidence gleaned from a detailed architectural examination of what is left of the pediment itself.

The Witness of Pausanias

It seems incredible that although the Parthenon served as a center of worship in Athens for a thousand years, only one writer's description of the Parthenon sculptures survives—that of the second-century AD travel writer Pausanias. He wrote only this about the east pediment:

All the figures in the gable over the entrance to the temple called the Parthenon relate to the birth of Athena.

This single sentence tells us the theme of the pediment and asserts that every piece of sculpture on it relates to that theme. Scholars have been unsuccessful in identifying most of the figures and relating them to Athena's birth because they fail to connect Athena with Eve and the story of Eden in the Book of Genesis.

The Left Side of the East Pediment

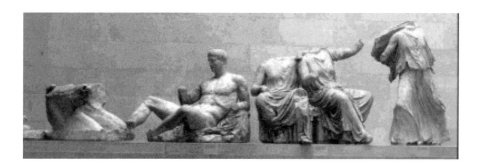

Above: sculptures from the left side of the east pediment in the British Museum; from the left: a charioteer and two horses (Figures A, B, and C), a naked, muscular male (Figure D), two heavily draped females seated on rectangular chests (Figures E and F), and a third standing female turning abruptly (Figure G).

Below: the same figures as drawn by Jacques Carrey in 1674. We can see by the position of Figure G's knee relative to the knee of seated Figure F that Carrey drew Figure G too large.

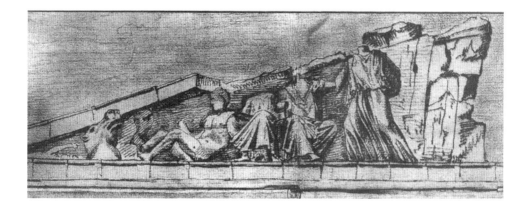

Details From the Left Side of the East Pediment

Figures A, B, and C. These figures are universally recognized as the remnants of Helios (the sun) and his quadriga (four-horse chariot).

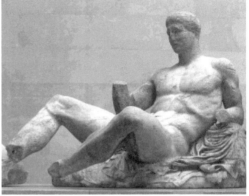

Figure D has been variously identified as Theseus, a hero who united Attika, Dionysos, the god of revelry and wine, and Herakles. We will see that only one of these scholarly guesses actually fits the theme of the pediment.

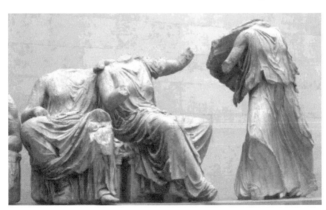

The usual identification of Figures E and F as Demeter, goddess of the earth's fertility, and her daughter Persephone is not correct because their presence here does not relate to the birth of Athena. The identification of G as Hebe, goddess of youth, or Artemis, goddess of the hunt is not correct either. Figure G in context lacks the stature of a goddess. And no one until now has been able to explain why E and F seem so at ease while the smaller G turns anxiously.

The Right Side of the East Pediment

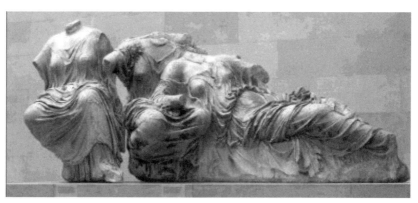

Above: in the British Museum, Figures K-L-M. Figure K, far left, is most often identified as Hestia, the goddess of the hearth. L is usually identified as the goddess Dione, with her daughter Aphrodite, M, reclining in her lap. No one has been able to explain their obvious indifference to Athena's birth. We'll see that these three are not Olympian goddesses at all, but rather, to the Greeks, familiar figures who form a collective iconograph representing paradise, or Eden.

Below: the same figures as drawn by Jacques Carrey in 1674. Note that Figures K and M still had heads then.

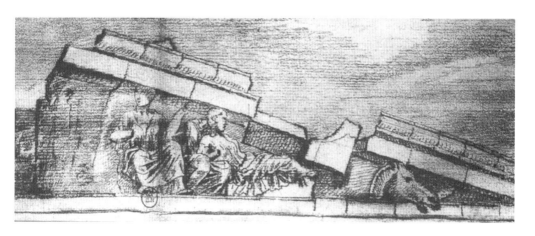

Sculptures from the Right Side of the East Pediment in the Akropolis Museum

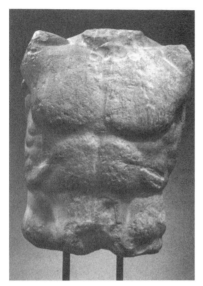

Some believe Figure H, left, is the torso of Poseidon, god of the sea, but the muscular structure itself identifies Figure H as Atlas, a Titan whose presence relates directly to the birth of Athena.

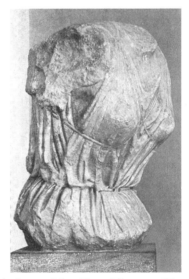

Above: the dimensions of this fragment and one other not shown put Hera, wife of Zeus, on the right side of the central scene on the east pediment.

Scholars identify Figure N, above, as the torso of the charioteer Selene—the moon, or Nyx—Night or Darkness. We'll see that only one of these beings fits perfectly with the cosmology of Hesiod and the birth of Athena.

Chapter 2
The Central Figures—Zeus, Athena, Hephaistos, and Hera

The Greeks depicted the birth of Athena in marble only on the Parthenon, and we know about that only from the words of the travel writer Pausanias: "All the figures in the gable over the entrance to the temple called the Parthenon relate to the birth of Athena." Of the birth scene itself in the center, we possess only the most fragmentary remains. Fortunately, we do have Athena's birth described in literature and painted on vases. Those sources make up the basis of our reconstruction.

We know from myth that Athena was born from the head of Zeus after he devoured Metis, the goddess of cunning. We also know from myth and many vase scenes that Hephaistos, the god of the forge, cracked open the head of Zeus with his axe to release Athena. We read in Pindar's *Seventh Olympian Ode*, written before the Parthenon was built: "By the skills of Hephaistos with the bronze-forged hatchet, Athena leapt from the top of her father's head and cried aloud with a mighty shout. The Sky and mother Earth shuddered before her." Thus Zeus, Athena, and Hephaistos must have been part of the central scene on the east pediment.

Hera, the wife of Zeus and queen of the gods, undoubtedly had a place there as well. To omit her from what we will come to see was an all-embracing theme, would have been unthinkable to reverent Greeks. Plus, there is ample physical evidence for Hera's presence in the central scene.

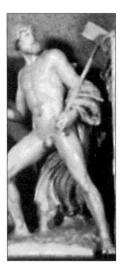

Above: from the east pediment reproduction on the Parthenon in Nashville, Tennessee, Hephaistos steps back after releasing Athena from Zeus' head with a violent blow of his axe.

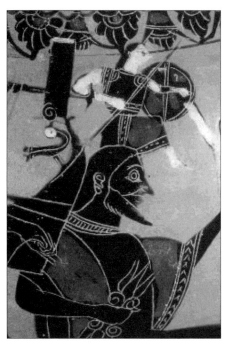

Above: black figure vase depiction from ca. 540 BC of Athena being born, fully-armed except for helmet, from the head of the seated Zeus who holds his lightning bolt in his right hand.

Zeus had intercourse with Metis, who turned many shapes in order to avoid his embraces. When she was with child, Zeus, taking time by the forelock, swallowed her, because Earth said that, after giving birth to the maiden who was then in her womb, Metis would bear a son who should be the lord of heaven. From fear of that Zeus swallowed her. And when the time came for the birth to take place . . . Hephaistos smote the head of Zeus with an axe, and Athena, fully armed, leaped up from the top of his head . . .

Apollodorus

But Zeus himself gave birth from his own head to bright-eyed Tritogeneia [Athena], the awful, the strife-stirring, the host-leader, the unwearying one who delights in tumults and wars and battles.

Hesiod, *Theogony*

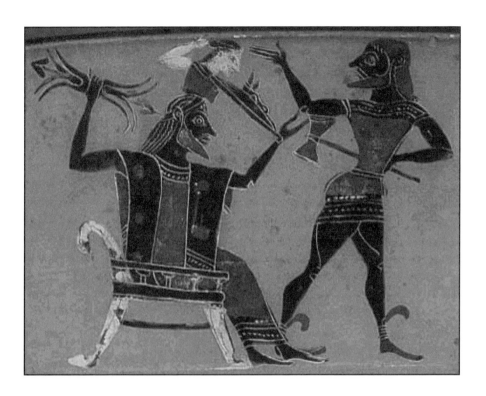

This scene from an Attic black figure cup from ca. 560 BC depicts the birth of Athena. Zeus sits on a throne, facing right. Both of his hands are raised in a gesture of presentation. His right hand clutches the lightning bolt, and his left hand is raised towards Hephaistos. From his head sprouts the head and upper torso of a slightly under life-size Athena carrying her shield. Hephaistos, carrying his axe, walks to the right, but twists his upper body back to look at Athena after playing his part in her birth. He gestures as if to say, "There, it is done!"

In this red figure vase depiction of the birth of Athena from ca. 450 BC, Hephaistos, moving to our right carrying his axe, looks intently at Athena's emergence the moment after he is said to have struck the head of Zeus. Athena (under life-size) emerges with her spear ready for immediate battle. The two women framing the scene are probably the *Eileithyiae*, goddesses of childbirth and children of Hera. Hera herself may be the figure at the far left.

Hera Joins Zeus, Athena, and Hephaistos in the Central Scene

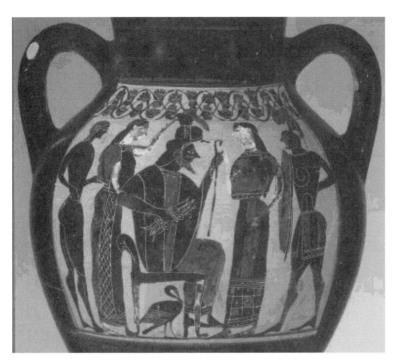

In this central scene from an Attic black figure vase from ca. 550 BC, Athena emerges from the head of the seated Zeus. In his right hand he holds a flaming lightning bolt; in his left, a scepter. Athena is fully dressed, and holds her shield and spear. To either side of Zeus stand the goddesses of childbirth, the *Eileithyiae* (plural), each wearing a patterned dress. These are daughters of Hera, sister/wife of Zeus and the chief goddess of childbirth. Behind the left-hand *Eileithyia* (singular) stands a youth; on the far right stands Ares. A swan stands under the chair of Zeus.

While it may have seemed appropriate on many "Birth of Athena" vases to have Hera's daughters present but not Hera herself, this would not do for the central scene of the east pediment of the Parthenon. The wife of Zeus and queen of the gods must have been represented prominently there. The technical evidence following bears this out.

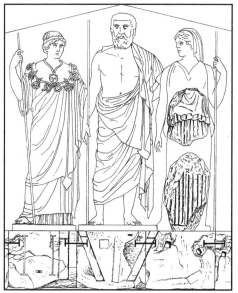

This drawing by K. Iliakis incorporates non-joining fragments believed to belong to the figure of Hera on the east pediment. Scholars refer to the combined fragments as "Peplos Figure Wegner" after the type of dress she is wearing and the man who first brought the pieces together. Olga Palagia writes of the figure, "Her striking simplicity, marking a vivid contrast to the baroque exuberance of the corner figures, is best explained by her colossal scale which entails a position close to the pediment axis." No other goddess save Hera herself belongs so close to Athena and Zeus in the center.

The majority of Parthenon scholars identify this largest of three fragments of the head of a goddess with the "Peplos Figure Wegner," and thus with Hera. Its dimensions are compatible. According to Olga Palagia, the largest fragment has been in the Akropolis Museum since at least 1890; a second non-joining fragment was recovered in 1984; and a third fragment joining the second came to light in 1990. The figure was turned to its proper right showing the spectator its left profile. The headband is pierced with two rows of holes running across in all fragments for the attachment of metal ornaments making a crown. The back of the head was covered by a veil indicating a matron. This is the head of Hera, queen of Olympus.

MOST LIKELY A STANDING ZEUS

Since Zeus is seated on vases depicting the birth of Athena, many scholars believe that he was sculpted that way in the center of the east pediment. But because of the weight of the marble, great technical difficulties plague such a possibility. Olga Palagia writes in her *The Pediments of the Parthenon*:

If the pediment represents the aftermath of the birth, there is a possibility that its designer might have departed from what we [scholars] consider the norm. A standing Zeus would eliminate some of the practical problems entailed by a colossal seated figure. [Kristian] Jeppesen sensibly points out that figures near the center of the pediments tend to be standing to reduce their depth. Since Athena is now by his side, Zeus has no reason to sit. He may be envisaged instead rising in response to Olympos' quake.

The vase painters showed the moment of Athena's birth, and wanted to emphasize that she sprang from the head of Zeus. This would have been an extremely difficult artistic challenge had Zeus been depicted as standing. Where would there have been space for Athena? On the other hand, sculpting a seated Zeus at the apex of a marble pediment with Athena in the process of emerging would have been very awkward, to say the least. The sculptors most probably followed the *Homeric Hymn to Athena* (see page following) and depicted her—not in the process of her birth—but after she had emerged and "stood before Zeus."

Furthermore, no Classical pediment is known to have carried a seated figure on its axis. In the center of the east pediment of Zeus' own temple at Olympia, completed ten to twenty years before the Parthenon, he is shown standing. Why would he be depicted differently on Athena's temple? As we shall see, the place for the colossal seated Zeus is inside his temple at Olympia.

> Athena sprang quickly from the immortal head and **stood before Zeus** who holds the aegis, shaking a sharp spear: great Olympus began to reel horribly at the might of the bright-eyed goddess . . .
>
> *Homeric Hymn to Athena*

Athena Zeus Hera Hephaistos

The central scene of the east pediment most likely followed the *Homeric Hymn to Athena*, depicting the moment the fully-formed Athena "stood before Zeus." Common sense would have us put Athena to the proper right of Zeus, Hera to his proper left, and Hephaistos to Hera's left, stepping back.

The Zeus in the center of the east pediment of the Parthenon may well have been modeled on the Zeus (above right) from the center of the east pediment of the god's temple at Olympia.

Now that we know the central figures on the east pediment were Zeus, Athena, Hephaistos, and Hera, let's move on and find out whom they truly represent.

Chapter 3
Athena—The Deified Eve

Callimachus wrote in his poem *The Baths of Pallas*, that because the seer Teiresias had accidentally caught sight of Athena bathing, he was summarily struck blind. The message: Athena must never be seen naked (and ashamed) but fully clothed and fully armed—victorious. Far from blinding us to reality, a glimpse of the naked Athena will begin to enlighten us as to her true identity, and the true identities of Zeus, Hera, Hephaistos, and the other gods. The doors of understanding will swing open into an intellectual and spiritual arena of unexpected breadth and depth. Our minds will be quickened and enriched with new contacts with truth. Greek religion, its gods and its myths,

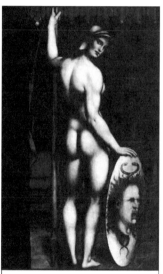

Athena by the School of Fontainbleau.

will begin to make sense to us. We shall see that Athena's great temple, the Parthenon, is the temple of Eve worshipped at the moment she accepted the serpent's wisdom as her own. That Athena is Eve may surprise us; but what should amaze us is the fact that so many scholars for so long have failed to see something so obvious.

THE WOMAN, THE TREE, AND THE SERPENT

Let's go back to Athens at the time of Sokrates and Plato, about 410 BC, 22 years after the completion of the Parthenon. To get to the great temple of the goddess Athena, we are going to have to climb to the Akropolis, the high place of the city. On the opposite page, we see Peter Connolly's reconstruction of it from the West.

As we pass through the *Propylaea*, or gateway, to the Akropolis, the huge bronze outdoor statue of Athena to our left front immediately attracts our eye. The ancients report that the tip of her spear could be seen gleaming in the sunlight far out to sea. Then our attention turns to our right—to the west façade of the Parthenon. But Athena's immense temple image is approached from the other end—the sacred east entrance. Therefore, we will note the images of Athena and Poseidon in the center of the west pediment as we pass it, and proceed along the 70-meter length of the north side of the temple. There, in a series of 32 metopes—individual sculpted scenes—we see the depiction of the sack of Troy by the Greeks. Then we turn the corner and arrive at the entrance to the temple of the great goddess Athena.

Let us imagine ourselves there as dawn breaks in mid-summer. The eight huge columns at the entrance, like the rest of the structure, are made of the purest white marble quarried from Mount Pentelikon ten miles away. As shadows of the night backtrack, the Parthenon absorbs the red of the rising sun behind us. We walk up the sacred steps and onto the porch. We pass between the central columns, and we enter through the open brass doors. Morning twilight turns orange. As we stand overwhelmed and astonished at what is before us, the sunshine spreads to flaxen yellow at a gallop, flooding the temple and illuminating the great image of Athena straight ahead of us, half a football field's distance. She stands nearly 40-feet-tall. Her arms, her feet, and her face are African ivory; her eyes, gleaming blue-green gems. Her image, carved from the wood of a great ebony cypress tree, is plated with milli-

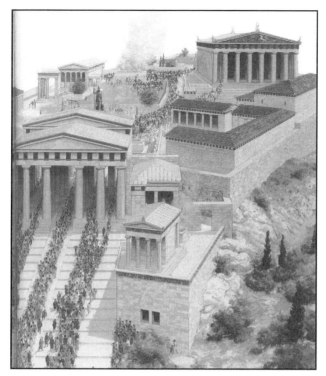

Peter Connolly's painting of the entrance to the Akropolis during the Panathenaic Festival, the annual celebration of the birth of Athena.

meter-thin, inlaid sheets of gold. Beneath her armor she wears a full-length tunic reaching to her feet. Worked in ivory on her breastplate, the head of the Gorgon Medusa glares at us. Her shield rests against her thigh. A huge, friendly serpent coils within its hollow. Upon her helmet, between winged griffins, crouches an inscrutable sphinx. In her right hand, she holds an image of Nike, or Winged Victory—the goddess associated almost exclusively with her and her father Zeus. Athena's left arm cradles a deadly spear.

She is a stupendous and awe-inspiring spectacle within a structure unrivaled in beauty and excellence—the most magnificent architectural

work of antiquity. Her fixed gaze exudes a calm and confident authority over the world of the Greeks.

Her temple has drawn more admiration from historians, archaeologists, poets, and dreamers than any other building in the world. It is truly amazing that so many have scaled these supreme heights and not seen something very simple beneath the spell-binding statue in this vast cathedral of human worship. Strip away the gold plates. Take away the gems and the ivory. Take away her war panoply and her presumption of victory. Without her Nike, without her armor and devoid of her glitter, we find something very basic: a woman, a tree, and a serpent. From the Judeo-Christian standpoint, we are back in Eden at the time of Eve's deception.

But the Greeks did not hold to the standpoint that Eve had been duped in paradise. To them, the serpent did not deceive Eve but, to the contrary, enlightened her, and through her, all of mankind. The serpent was not an enemy of Eve, but rather, her best friend. The Greek idea was that, far from being the seducer of the race, the serpent was our first schoolmaster and civilizer by teaching us the difference between good and evil. The Greeks regarded what Christians and Jews today consider to be the sin of Adam and Eve as a positive transition from the state of unconscious bondage to the state of conscious judgment and freedom; and therefore the necessary entrance of the good, and a noble advance of the human spirit. They regarded the Creator of the world as an oppressive being, whom to resist was considered a virtue. They glorified His adversary, the serpent, as the liberator and illuminator of humanity.

This liberation and illumination is a victory over the God who for some time had been successful keeping both Eve and Adam away from the tree and its knowledge of good and evil—a knowledge essential to humanity's understanding of itself. This is the significance of the Nike Athena displays in her right hand—the hand of power. Nike boasts of the serpent's victory through Eve's willingness to eat of the tree that set humanity free.

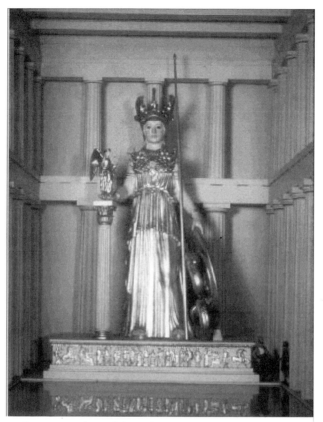

Reconstruction of the Athena Parthenos in the Royal
Ontario Museum, Toronto.

To the Greeks, Athena was Eve glorified and worshipped as the one
who made human consciousness as we know it—with its knowledge of
good and evil—possible. With this consciousness came a developing
civilization; and naturally, the human who initiated the process took an
exalted place in this religious system. Now, if Athena is indeed the Eve
of Genesis immortalized by the Greeks as a positive spiritual force for
humanity, we ought to find this truth expressed by her worshippers in
many ways. And as we shall see, we do.

ATHENA'S NAME REVEALS
HER TRUE IDENTITY

The meaning of Athena's name relates directly to the words the serpent spoke to Eve in the Garden of Eden. In Genesis 3:4, the serpent promised her that when she ate of the fruit of the tree of the knowledge of good and evil "not to die shall you be dying." Consider then, what follows. In the most ancient Greek writing, the name of the goddess first appears as Αθανα, or in our Latin letters, Athana. In the Greek language alpha (α) or "a" at the beginning of a word often has the same significance as "un" or "non" in English. We can see this in many Greek words that have come directly into our language. A theist believes in God; an a-theist does not. A gnostic has knowledge; an a-gnostic lacks knowledge. The word θανατοσ (thanatos) in ancient Greek means death. A-θανατοσ (A-thanatos) signifies deathlessness. A-thana is the shortened form of A-thanatos meaning the deathless one, or more specifically, the embodiment of the serpent's promise to Eve that she would never die, but would be as the gods, knowing good and evil. Through Athana, later called Athena, the serpent has made good his promise to Eve.

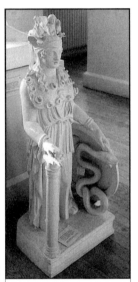

Roman copy of Athena Parthenos (Nike missing from pedestal).

Eve and Athena

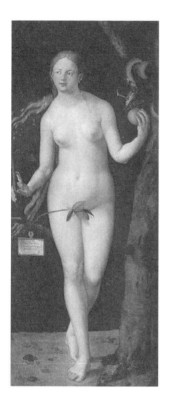 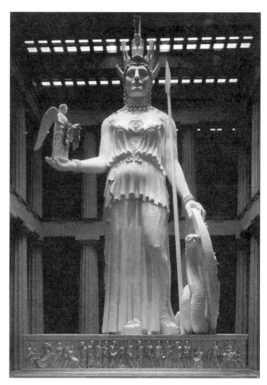

Albrecht Dürer's painting (left) of the crucial event in Eden, shows us a woman, a tree, and a serpent. Eve, the woman, holds the fruit she has just picked. Athena's idol-image, at its core a tree, depicts the meaning of that event for the Greeks. Because of her trust in the promise of the serpent, who coils as a companion by her side, Eve has become the immortal A-thana (tos). The Greeks celebrated the taking of the fruit as the great victory for mankind, and so Athena holds Nike in her right hand, and stands fully armed to protect and defend that victory for humanity.

The Head of Serpents Signifies the Source of Athena's Authority

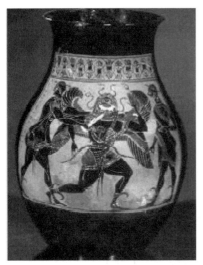

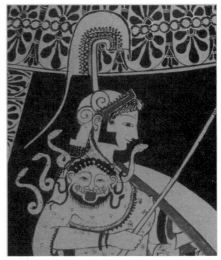

Perseus cutting off Medusa's head as Hermes looks on, Attic black figure vase, ca. 550 BC. After a series of adventures, Perseus presented the head of serpents to Athena, and she wore it on her aegis as a sign of the source of her authority.

Athena depicted on an Attic red figure *amphora* (storage jar) from ca. 525 BC. Her aegis is positioned over her right shoulder so that the Gorgon head—the head of serpents—is seen in full frontal-face. The look of the Gorgon Medusa had the power to turn men to stone.

Overcoming the Curse of the Gorgon Medusa

According to the myth, when Perseus cut off the Gorgon's head, he did not look directly at her or he would have turned to stone. He used his polished shield to view her indirectly, negating the power of her gaze. This same technique is needed today to overcome the Gorgon's curse. Thousands of writers and teachers of mythology look directly at Athena. The stare of the Gorgon on her aegis turns their minds figuratively to stone—a kind of mental paralysis sets in. In this intellectual stupor, they are unable to recognize Athena as the serpent's Eve. Only when we look at Athena's image indirectly, as it is reflected from the Book of Genesis, are we able to get a true picture of her identity, and understand her role in Greek religion.

Athena—Goddess of the Serpent's Wisdom

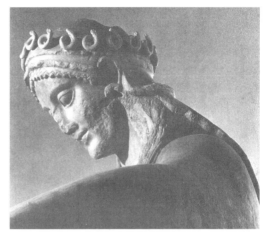

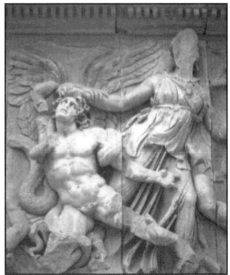

On the previous page, we see the head of serpents displayed on Athena's aegis. On this page from the left, we see the huge serpent inside Athena's shield from her Parthenon idol-image, the head of Athena from the archaic temple of Athena on the Akropolis wearing a crown of serpents, Athena and the serpent killing the Giant Enkelados from the frieze at Pergamum, and on the following page . . .

Athena—Goddess of the Serpent's Wisdom

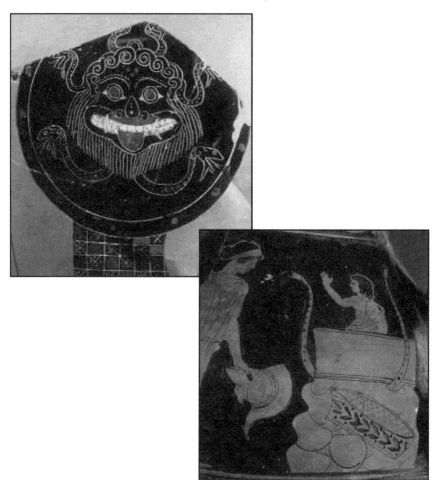

. . . we see the head of serpents as a symbol of defense on Athena's shield, and Athena with her stepchild Erichthonios who is protected by serpents, or more likely, by a single two-headed serpent. According to the schoolbooks, Athena is the Greek goddess of wisdom. But as these illustrations show, Greek sculptors and painters knew her as the goddess of the serpent's wisdom. To them, Athena represented the wisdom of the serpent and the power of the serpent.

Chapter 4

Zeus—the Transfigured Serpent

I have suggested that Athena is Eve glorified and worshipped by the Greeks as the one who brings to them the serpent's enlightenment. Figuratively, the serpent fathered Eve. He coaxed her out of Yahweh's family, and welcomed her into his own. If Athena is indeed Eve, and if this east pediment depicts Eden from the serpent's viewpoint, then Zeus, Athena's father according to Greek myth, must be the serpent in a different form. Both anthropology and Scripture back up this idea.

John C. Wilson wrote that anthropologist Jane Ellen Harrison "understood, as no one did before her, that in spite of their great intellectual achievements the Greeks belonged in the main to the world of primitive religion." The superstitious Greek, she thought, entered the presence of his gods as though he were approaching the hole of a snake, for the snake had been to his ancestors, and was still to him and many of his contemporaries, literally and actually a god. A lifetime of study led her to believe that Greek religion, for all its superficial serenity, had within it and beneath it elements of a deeper and darker significance. She concluded that Zeus, the Olympian father god, had tended to erase from men's minds the worship of himself when he bore the title Zeus *Meilichios*, Zeus "Easy-to-be-entreated," and took the form of the serpent who demanded from his devotees the sacrifice of a pig.

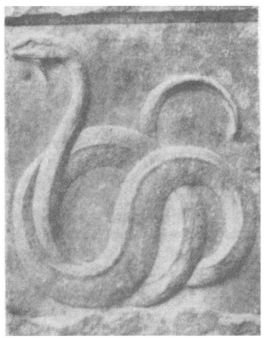

The relief to the left and the one on the next page were found at Athens' harbor, and date from the 4th century BC. Inscribed above this coiled beast is "to Zeus *Meilichios*," meaning "to Zeus the easily entreated one." The beard signifies "the ancient serpent."

Ms. Harrison examined several ancient stone reliefs of a coiled serpent twice human size inscribed to Zeus. In her *Prolegomena to the Study of Greek Religion*, she wrote:

We are brought face to face with the astounding fact that Zeus, father of gods and men, is figured by his worshipers as a snake . . . The human-shaped Zeus has slipped himself quietly into the place of the old snake-god. Art sets plainly forth what has been dimly shadowed in ritual and mythology. It is not that Zeus the Olympian has an "underworld aspect"; it is the cruder fact that he of the upper air, of the thunder and lightning, extrudes an ancient serpent-demon of the lower world, Meilichios.

As we have seen, from the earliest times the Greeks took a view of the serpent opposite the one we generally hold today. To them, the serpent freed mankind from bondage to an oppressive God, and was therefore a savior and illuminator of our race. The Greeks worshipped Zeus as both savior and illuminator; they called him Zeus *Phanaios* which

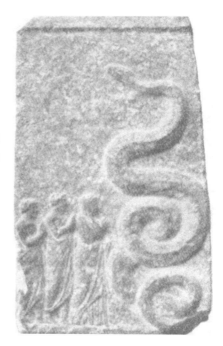

In the figure to the right, a woman and two men approach Zeus as the serpent with gestures of adoration.

means "one who appears as light and brings light."

What Zeus itself means is very revealing in this regard. Edward Tripp and others say simply that the name is derived from an Indo-European root meaning to shine or gleam brightly. According to Carl Kerenyi, Zeus, the supreme god of the Greeks and their history, has a transparent name which more directly betrays his place in Eden. In his book *Zeus and Hera*, Mr. Kerenyi writes that "the actual content of the word *Zeus* is the *moment* of lighting up." He adds:

> **By the content of his name, "lighting up," Zeus was connected for the Greeks not with the beginning of the world but with the time of which they themselves had historical consciousness, a "new" time contrasted with an "old" time which was not yet ruled by Zeus.**

The "old" time is that time when Yahweh ruled, before Eve ate the fruit; the "new" time comes after Eve picks the fruit and the serpent begins his rule. Eve's moment of disobedience from the Judeo-Christian point of view, was to the Greeks the instant she welcomed

enlightenment from the serpent—the moment of lighting up, the moment civilization and culture became possible. And with that possibility came the Greek expectation that the serpent's system would raise humanity higher in the scale of creation.

The Scriptures express this more concisely. Revelation 12:9 identifies the "ancient serpent" by the titles Adversary and Satan, and the apostle Paul in II Corinthians 11:14 asserts that "Satan himself [i.e. the ancient serpent] is being transfigured into a messenger of light."

Zeus, the god of thunder and lightning, ruled the sky. To the Greeks, his was the sphere of atmospheric phenomena—the air. Scripture matches Greek myth here as well. We read in Ephesians 2:2 that the Adversary (Zeus the transfigured serpent) is "the chief of the jurisdiction of the air."

Greek myth portrays Zeus as the supreme power over all the earth. In Homer, Zeus towers over every other god and goddess and every human order with absolute pre-eminence. Zeus is the one who makes kings and kingdoms. What power Homer gives to Zeus, Scripture gives to Satan. After fasting in the wilderness for forty days and forty nights, Christ encounters the Adversary, sent there to try Him. Matthew 4:8-9 reads:

Again the Adversary takes Him along into a very high mountain, and is showing Him all the kingdoms of the world and their glory. And he said to Him, "All these to you will I be giving, if ever, falling down, you should be worshipping me."

Jesus does not at all dispute the Adversary's express claim that he is ruler of all the kingdoms of the world. The "very high mountain" from which the Adversary makes his offer reminds us of the mythical home of Zeus: Mount Olympus. This mountain characterized the rule of Zeus religion from the beginning, all the more so in Classical and Hellenistic times when it had become the seat of Father Zeus' entire family of gods and goddesses.

Revelation 2:13 also identifies the ancient serpent who is known as the Adversary and Satan with Zeus. In that verse, the Son of God

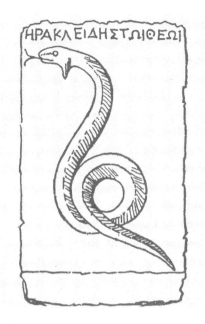

ΗΡΑΚΛΕΙΔΗΣΤΛΙΘΕΩΙ

Right: relief of the bearded serpent from the sanctuary at Athens harbor. The inscription reads, "Heracleides to the god." Jane Ellen Harrison writes of it, "When and where the snake is simply 'the god,' the fusion with Zeus is made easy."

speaks to His Jewish followers in the Ionian city of Pergamum saying, "I am aware where you are dwelling—where the throne of Satan is." Pergamum, near the coast of modern-day Western Turkey, about 50 miles south of ancient Troy, was one of the most beautiful of ancient Greek cities. There, atop a mountain, just above a great amphitheater built into the side of it, 20 miles from the Aegean Sea, stood the magnificent 40-foot-high Altar of Zeus. The throne of Satan—the throne of the ancient transfigured serpent—is the Altar of Zeus. See pages 44 and 45, following.

The case for the identity of Zeus as the serpent is yet further strengthened when we consider that the idol images of Athena, Apollo, Hermes, Hephaistos, Hera, Artemis, and other Greek gods often appeared attended by serpents, but Zeus never. Why? The presence of snakes around the other gods indicated that they were part of the serpent's system of enlightenment and sacrifice. But Zeus is not part of the serpent's system—He *is* the serpent.

The Altar of Zeus—The Throne of Satan

Pergamum began its rise to prominence in 283 BC, about half-a-century after the death of Alexander the Great. The kings of Pergamum looked across the Aegean Sea to Athens for their inspiration. They made Athena their "protectress of the state," building her a temple on the heights 300 meters above the city and calling her *Nikephoros*, the bearer of victories.

King Eumenes II ordered the great Altar of Zeus built as a votive offering to both Zeus and Athena after military victories over the Galations in 183 BC. It was most likely completed in 178 BC. The outer friezes depicted the gods, led by Zeus and Athena, defeating the Giants. These mythological beings, as we shall see in chapter twelve, represented the faithful sons of Noah.

In about 70 AD, the apostle John referred to the Altar of Zeus in Pergamum as "the throne of Satan."

The great Altar of Zeus remained intact until the tenth century. Then, the Byzantines used many parts of the altar, including the frieze plates, to construct a defensive wall on the fortress-hill in their war against Islam, and the ancient treasures gradually disappeared into the dirt.

In the early 1870's, a German engineer named Carl Humann who had been hired to build a highway in Asia Minor, was drawn to Pergamum where he discovered and unearthed some of the frieze plates. In 1878, a planned excavation of the fortress-hill terrain began under Humann's direction. Over the years, the Germans conducted negotiations with the Turkish government, making possible the acquisition of the Pergamum findings for the Berlin Museum. There, in 1880, some sculptures were shown for the first time. It was not until 1930, however, that the western side of the Altar of Zeus, the throne of Satan, was erected in a room in the newly built Pergamum Museum. Shortly after that, Adolph Hitler, a man determined to eradicate Yahweh's chosen people, seized

power. The Nazi Chief of Church Affairs, Hans Kerrl, announced, "There has arisen a new authority as to what Christ and Christianity really are—that is Adolph Hitler. Adolph Hitler is the true Holy Ghost." The rest of the story you should know.

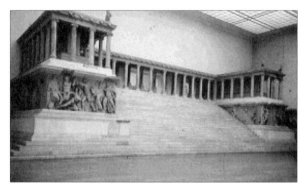

Pergamum Altar of Zeus as reconstructed in Berlin.

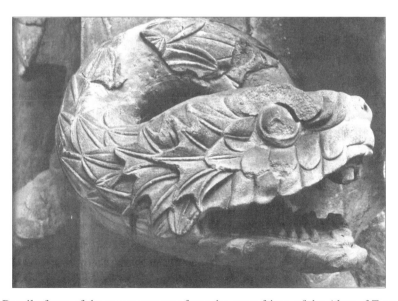

Detail of one of the many serpents from the outer frieze of the Altar of Zeus which depicts the Greek gods defeating the Giants who, we shall see, represent the Yahweh-believing sons of Noah.

The Two-headed Serpent Heralds the Edicts of Zeus

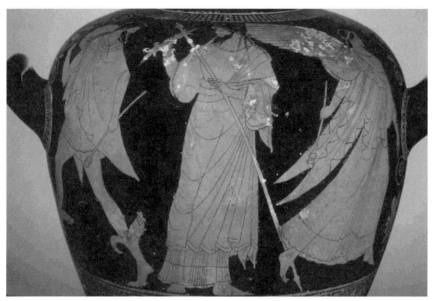

On this Attic red figure *stamnos* (large wine jar) from ca. 475 BC, Zeus, holding his scepter and lightning bolt, sends forth his two primary heralds, Hermes (left) and Iris. Each of them carries a *kerykeion*, or herald's staff (*caduceus* in Latin). The kerykeion features a serpent with two heads facing each other symbolizing the serpent's rule over the past and the future. The kerykeion identifies the authority of Zeus with the authority of the serpent.

In hundreds of surviving ancient vase depictions, Hermes almost always carries his *kerykeion*, a sign that he is the chief messenger of Zeus. When we get to Hermes and his place on the east pediment, we'll see that he is a deification of Cush, the original postdiluvian prophet of the serpent's wisdom from Babylon.

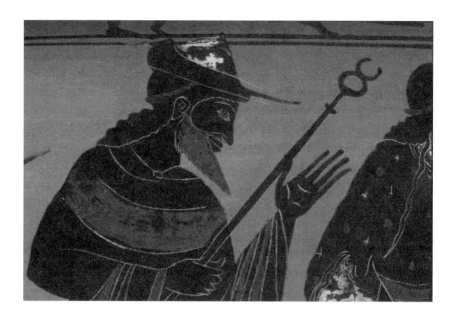

Above: On an Attic black figure *hydria* (water jar) from ca. 525 BC, Hermes carries his kerykeion and wears his *petasos*, or traveling cap. Right: On an Attic red figure vase from ca. 325 BC, Hermes holds his kerykeion with both hands.

The One Who First Established the Religion of Zeus in Athens is Depicted as the Serpent's Man.

The history of Athens is told in many versions, none of them earlier than the fifth century and seldom in agreement with one another. One of the few undisputed points is that Kekrops was the city's first recorded king. He reflects Athens' claim to autochthony [local earth-born rule] in that no parentage is named and he was imagined as human only from the waist up, the rest a long snaky tail.

H. A. Shapiro in *Pandora*

Left: Kekrops, the first king of Athens, from an Attic red figure cup ca. 440 BC. He is looking on at the birth of his adopted son and successor, Erichthonios.

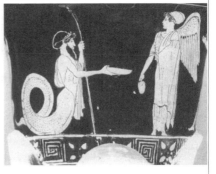

Right: On this drinking cup from Athens, we see Kekrops holding the scepter of kingship. In his other hand he extends a *phiale* (ritual drink-offering bowl) to Nike, who will fill it from a jug. That a half-man, half-serpent (the serpent's man) has brought the serpent's religious system to Athens is figured in this depiction as a great victory (Nike) for the Greeks. Thus, in a rare tribute to a mortal, Nike here pours out a sacrificial libation to Kekrops.

The Transfiguration of the Serpent into Zeus May Be the Central Architectural Message of the Parthenon

 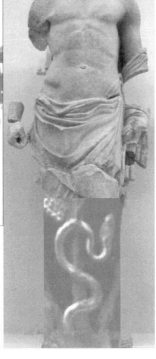

The Greeks' first view of the Parthenon as they entered through the gateway to the Akropolis was the west façade. Athena and Poseidon appeared facing each other in the center of that pediment. A depiction of that on a 4th-century BC *hydria* (water jar) now in the Hermitage Museum in St. Petersburg, Russia (above left) shows a serpent coiled around a tree between Athena and Poseidon—which would have put the serpent in the very center of that pediment. When we follow the long axis along the roof of the temple from the west pediment to the east pediment, we find Zeus standing in the very center of it. In the space of seventy meters, the serpent has taken the form of a human and become the father of gods and men.

Above right, the serpent from the vase depiction of the center of the west pediment has been superimposed on a sculpture of Zeus from his temple at Olympia, most likely similar to the Parthenon sculpture of Zeus in the center of the east pediment.

Zeus, the Transfigured Serpent, is a Picture of Adam at the Moment of Lighting Up

Greek religion is a sophisticated form of ancestor worship. With the exception of some natural elements and forces, such as the North Wind and the sea, the gods are deifications, or immortalizations, of historical humans. Sokrates frankly acknowledged his physical descent from the gods as deified humans in this bit of dialogue from Plato's *Euthydemus*:

> **"No matter, said Dionysodorus, for you admit you have Apollo, Zeus, and Athene."**
>
> **"Certainly," [Sokrates] said.**
>
> **"And they are your gods," he said.**
>
> **"Yes," [Sokrates] said, "my lords and ancestors."**

In the Book of Acts, the apostle Paul, citing Greek literary sources, asserts categorically that the race of the gods and the race of men are one and the same. In chapter 17 he stands on the Areopagus (the Hill of Ares, across from the Akropolis), and speaks to the inquisitive group gathered there:

> **"Men! Athenians! On all sides am I beholding how unusually religious you are. For, passing through and contemplating the objects of your veneration, I found a pedestal also, on which had been inscribed, 'To an Unknown God.' To Whom then you are ignorantly devout, This One am I announcing to you."**

When Paul says these Greeks are unusually "religious" he means fearful, for the Greek word is *deisidaimon*, literally dread-demon. Zeus-religion was so systematized by Paul's time that it completely obscured the knowledge of Yahweh. Paul attempts to reveal this Unknown God to them, and at the same time expose the futility of idol worship:

". . . [N]ot far from each one of us is He [the Unknown God] inherent, for in Him we are living and moving and are, as some poets of yours also have declared, 'For of that race also are we.' The race, then, is inherently of God; we ought not to be inferring that the Divine is like gold, or silver, or stone sculpture of art and human sentiment."

The exact words "For of that race also are we" occur as part of an invocation to Zeus in a little book called *The Skies* by Aratus (315 – 245 BC) of Cilicia (Paul's native province). Aratus thus asserts that his race and the race of Zeus are one and the same. The Stoic Cleanthes (331 – 232 BC) also uses the phrase in his *Hymn to Zeus*. The Greek word used by Paul and the poets translated race is *genos*. It refers specifically to the race of mankind, making Zeus, in context, part of that race. The race of Zeus and the gods is the race of deified, ancestral men and women.

So then, what man does the figure of Zeus represent? To arrive at the very obvious answer to this question, let's review. We've seen that in the Greek religion the serpent took the form of a very powerful-looking father-figure armed with lightning bolts. Both the serpent and the human image had the name Zeus, meaning "the moment of lighting up," or more explicitly according to Carl Kerenyi, "the actual decisive, dynamic moment of becoming light." This meaning of Zeus' name has led us directly back to the Garden of Eden and the time when Eve and Adam accepted the serpent's wisdom as their own. It should not surprise us that the enlightener in Greek religion should find suitable human representation for himself right there in the Garden.

Unlike Eve, Adam did not need to be convinced of the efficacy of eating the fruit: ". . . and [Eve] is giving, moreover, to her husband with her, and they are eating" (Genesis 3:6). He may well have desired to possess the knowledge of good and evil for himself for some time before he actually partook. Adam was the enlightener's very first male convert and the progenitor of the entire human race as well. It made sense for the enlightener to represent himself to humanity by means of the image of Adam—a messenger of his (the serpent's) light.

Homer says that Zeus is "the father of gods and men." All humans, living or dead, including those dead who are deified in Greek religion, are descended from Adam, the first man. Zeus, then, is not only a transfiguration of the serpent, but a picture of our first human father, Adam, as well.

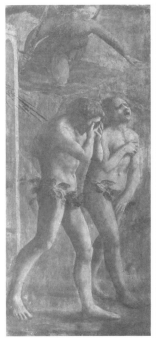 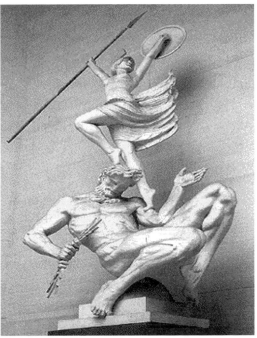

Above we see the same event depicted from the Judeo-Christian standpoint, and that of Greek religion. In the fresco by Masaccio, shame characterizes the scene. In the sculpture by Tegner, triumph reigns. Athena is born out of Zeus just as Eve came out of Adam, and she has come out exulting in the serpent's enlightenment!

Chapter 5

Hera—The Primal Eve

Athena is a deification of Eve, but so also is Hera. Hera represents the serpent's Eve before the Flood, and Athena represents the *rebirth* of the serpent's Eve after the Flood.

Zeus and his wife (first known as Dione and then Hera) are deifications of Adam and his wife Eve. Greek myth matches the narrative of Genesis insofar as Eve's creation is concerned. Adam is in paradise, but he is lonely; Yahweh has not yet made "a helper as his complement." And so He set about that work:

And falling is a stupor on the human, caused by Yahweh Elohim, and he is sleeping. And taking is He one of his angular organs and is closing the flesh under it. And Yahweh Elohim is building the angular organ, which He takes from the human, into a woman, and bringing her is he to the human. And saying is the human, "This was once bone of my bones and flesh of my flesh. This shall be called woman, for from her man is this taken." Therefore a man shall forsake his father and his mother and cling to his wife, and they two become one flesh (Genesis 2:21-24).

The Greek counterpart of this event shows up at the ancient oracle in Dodona in the mountains of Epirus in the north of Greece where, as far as scholars can tell, the Greek worship of Zeus began. According to the

One of the two temples of Dione, the first sister/wife of Zeus at Dodona, the oldest known site of his worship. Genesis asserts that Eve came out of Adam. Dione is the feminine form of Dios (Zeus), suggesting that they, too, were once a bisexual unity.

cultic myth, a pigeon flying from Egyptian Thebes had lighted on an oak tree at Dodona, and with human voice directed the founding of an oracle of Zeus. By the rustling of the oak's leaves, priests and priestesses divined the will of the god and his wife, Dione. It is her name which reminds us of the creation of Eve, for Dione is the feminine form of Dios, or Zeus. The meaning of both names points to "the moment of lighting up" in Eden, and suggests that the two were once, like Adam, a single bisexual entity.

Throughout the rest of Greece, the deification of Eve took the name Hera. She was an ancient pre-Hellenic goddess whose Greek name means "lady." As Eve immortalized, Hera would, indeed, have to be the preeminent lady. According to Homer, she and Zeus were children of Kronos and Rhea. Rhea is the earth. It is not difficult to see that Adam's "mother" (and therefore Eve's as well) is the earth:

And forming is Yahweh Elohim the human of soil from the ground, and he is blowing into his nostrils the breath of the living, and becoming is the human a living soul (Genesis 2:7).

But who was Kronos? Robert Graves says Kronos means crow, and there doesn't seem to be any connection to Eden. We should, then, consider this: the Greek letters kappa (k) and chi (x) sound the same at the beginning of a word; therefore, the Greek word Χρονοσ (Chronos)

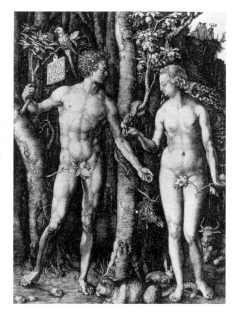

Adam and Eve by Albrecht Dürer. The beginning of the family of man and the origin of the family of the Greek gods.

would sound the same as Kronos. And Chronos, which probably was the original name of the father of Hera and Zeus, means time. It's where we get our word chronology, for example. Yahweh is used hundreds of times in the Hebrew to represent the Supreme God of the Scriptures. It means the Self-Existent One. Yahweh derives from the Hebrew *hâyâh* which has within itself the concepts of past, present, and future—was, is, and will be. Kronos as a misspelling of Chronos could very well be Greek religion's equivalent of Yahweh, the Lord of Time. Zeus is the eldest son of Chronos and Hera is his eldest daughter. As such they are brother and sister.

Adam and Eve are the first couple according to Genesis. Zeus and Hera are the first couple according to Greek myth. Zeus' and Hera's qualities are very, very human. They get angry and resentful. They drink, eat, and party. They become jealous, even furious at times. They make love, and Zeus, in particular, lusts and is unfaithful. In the Greek world, Zeus and Hera are historically and archetypally united as if they were a human pair. The reason for this is obvious: they were originally an actual human pair. They are the original human couple, Adam and

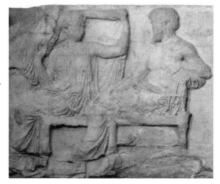

Hera and Zeus from the east frieze of the Parthenon, ca. 438 BC.

Eve, immortalized as the father and mother of all humanity. Understanding this elementary truth of Greek religion, we can say with Paul, Aratus, and Cleanthes, "For of that race also are we." Zeus and Hera are Greek images of our ancestors Adam and Eve.

The sacred marriage (*heiros gamos*) of Zeus and Hera according to Greek myth points to their deification as Adam and Eve. The Greeks understood this marriage of their two greatest ancestors to be a prototype of human marriage. The Athenians dedicated the month *Gamelion* (meaning "marriage month") to Hera and sacrificed to her and Zeus *Heraios* (Zeus the husband of Hera). The reenactment of Hera's sacred marriage to Zeus was the most characteristic rite of the goddess in the Greek world. Athenians celebrated it every year on the twenty-sixth of Gamelion.

The problem was that, as a brother and sister union, it violated the strict Greek incest taboo. While on rare occasions children with the same father but different mothers could wed, no Greek bride was allowed to marry a brother who had the same mother as herself. And yet Hera was allowed to transgress this prohibition. Why? Not only does she marry her brother, Zeus, but she becomes the goddess of marriage! Such a marriage is anything but an imitation of human custom—just the reverse—an outright violation of it. The sacred marriage of Zeus and Hera is the one great and shocking exception to the incest taboo.

The marriage of this brother and sister pair doesn't make any sense unless we see it as the reporting of an older mythologem, a story

56

On this Attic red figure vase from ca. 490 BC, Hera sits enthroned with her scepter. Although Athena supersedes Hera in authority during the Greek age, she is never pictured enthroned, out of deference to the primal Eve and queen of the gods.

grounded in the reality of the past, a tradition telling the truth about the first couple. The fact that, according to Greek myth, Hera received golden apples as a wedding present from either Earth or Zeus, demands that we look to Eden for the explanation. That is where we find the source of the sacred marriage rite. As the first humans, Adam and Eve were brother and sister. And yet they became husband and wife. The annual celebration and reenactment of the marriage of Zeus and Hera could only have been performed in honor of the original marriage of Adam and his sister Eve.

The Greeks also performed the ritual reenactment of the sacred marriage of Zeus and Hera to ensure fertility. Of course! What more logical pair to propitiate for healthy offspring than the progenitors of the entire race of mankind! Who could ever have more descendants than they?

We can't expect the Greeks to tell the story of Eden in the same way that Genesis does. Their standpoint is different and their sources do not make up a theoretically consistent body of literature. If the Eden story is true, however, we should expect to find bits and pieces of it throughout Greek myth. And we do.

One myth of the "birth" of Zeus says that because of the determination of Chronos to destroy the pregnant Rhea's offspring, she had to flee to Crete in order to save her child Zeus from his wrath. There is a connection between the birth of Zeus (Adam welcoming the serpent's wisdom and his system) and a need to hide from Yahweh. The time and the place are off, but the idea of hiding—associated with shame from the Judeo-Christian viewpoint—is there nonetheless.

Zeus and Hera bickered constantly. Persistent stories of quarrels between the divine pair in myth may reflect the faint memory of the actual state of the marriage of Adam and Eve. They had serious problems with their children (their first-born murdered their second-born) and each undoubtedly could have found good reason to blame the other for the tree incident and the woes that followed.

Myth points directly to Zeus as an image of Adam, and Hera as an image of the primal Eve. Who else could they be?

A wooden loving couple from the island of Samos ca. 620 BC, height 18 cm. An eagle between their heads, a symbol of the king of the gods, suggests that this is Zeus and Hera—a picture of Adam and Eve, the first couple.

Hera is the Primal Eve and Athena is the New Eve of the Greek Age

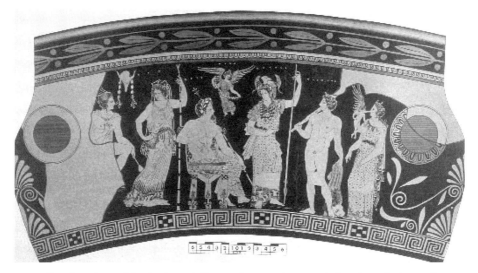

Depicted on this Attic red figure *krater* (large mixing bowl) from the Classical period, above, and enlargements on the following pages, we see Herakles entering Olympus. It is a vase painting that makes it very easy to explain how Hera and Athena are both deifications of Eve, and to understand the difference between them.

First, the background. The Greeks knew that there had been a great Flood over the entire earth. As we shall see in the next book in the series, they depicted the Flood and its aftermath on the west pediment of the Parthenon. Instead of Noah and his family, their survivors of it were Deucalion and Pyrrha. And it wasn't Yahweh who caused the Flood, but Zeus. The Greeks also had their own understanding of this curse from Genesis:

And enmity am I setting between you [the serpent] and the woman [Eve], and between your seed and her seed. He shall hurt your head and you shall hurt his heel (Genesis 3:15).

(Continued on page 63)

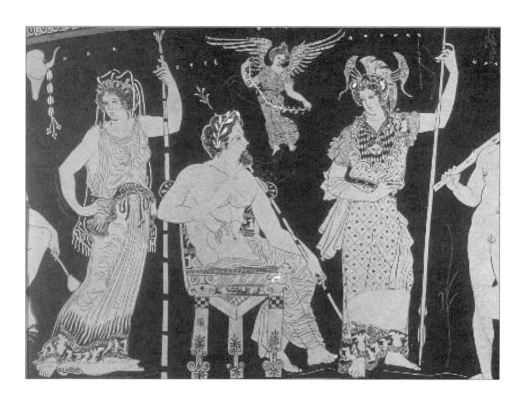

Zeus, the king of the gods, looks to Athena and ignores a disgruntled Hera as they welcome Herakles to Olympus. Eve was the first mother and first wife, deified as Hera, goddess of childbirth and marriage. Athena, as the deification of Eve in the new Greek age, will not marry and will not have children—breaking the curse found in similar forms in Genesis, Hesiod, and Apollodorus. She is the Eve who welcomes and embodies the transfigured serpent's wisdom and power. Nike's presence between Zeus and Athena attests to their victory.

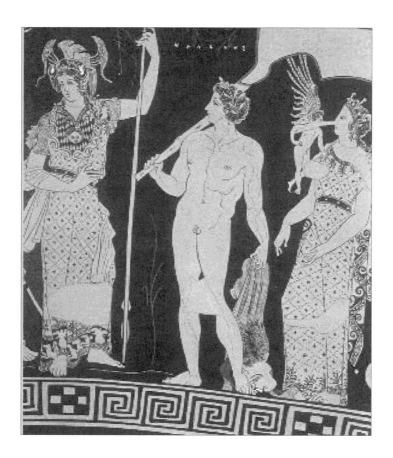

The immortal Herakles appears naked and unashamed, holding his lion skin, as he looks toward his gods and patrons, Athena and Zeus. We'll see that Herakles is actually the master hunter and first king of humanity from Genesis, Nimrod, transplanted to Greek soil.

Hera stares at Hermes with a look of blame. As we proceed, we shall see that Hermes is the deified Cush, and is indeed largely responsible for the new order of Zeus-religion after the Flood, an order which pushes Hera into the background.

(Continued from page 59)

According to Hesiod, "Earth and starry Heaven" warned Zeus of an almost identical curse. To avoid it, they urged him to swallow the goddess Metis whose name means cunning, for "she was to bear a son of overbearing spirit—king of gods and men. But Zeus put her into his own belly first, that the goddess might devise for him both good and evil."

Apollodorus told a similar story:

Zeus had intercourse with Metis, who turned many shapes in order to avoid his embraces. When she was with child, Zeus, taking time by the forelock, swallowed her, because Earth said that, after giving birth to the maiden who was then in her womb, Metis would bear a son who should be the lord of heaven. From fear of that Zeus swallowed her. And when the time came for the birth to take place . . . Hephaistos smote the head of Zeus with an axe, and Athena, fully armed, leaped up from the top of his head . . .

The birth of Athena breaks the curse. Zeus, the transfigured serpent, has granted immortality to Eve as Athena Parthenos, Athena the maiden, Athena the virgin. As such she will have no children, no seed to threaten her father, and the reign of Zeus is secure.

Now, let's look back at our vase painting. Herakles, shown naked with his club after having completed his twelve labors, has become immortal and entered Olympus as his reward. Next to him stands his wife Hebe (Youth). An *erotes* hovers between them indicating their love and happiness. Hera, hand on hip, looks away from Zeus and Athena in the center toward Hermes with a glare of discouragement, or perhaps disappointment. But why? The answer is that throughout Herakles' life and labors, Hera opposed him, while Athena assisted him. The vase painting on the following page shows that Hera went so far as to send snakes to try to kill Herakles as a baby in his crib. Hera represents the old order; Athena represents the new. The completion of Herakles' labors repre-

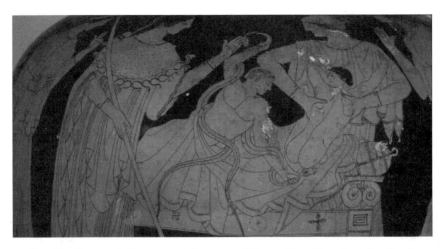

On this Attic red figure vase from ca. 475 BC, Herakles strangles the two snakes sent by Hera to kill him in his crib. His twin brother, Iphikles, reaches out toward their frightened mother, Alkmene. Athena, with her serpent-trimmed aegis, stands by, calmly extending her left arm over the crib signifying her protection of Herakles.

sents the reestablishment of the serpent's system after the Flood, and the transfer of power from Hera to Athena.

As his final labor, Herakles obtained the three golden apples of the Hesperides from a serpent-entwined tree. They represented the fruit of the tree of the knowledge of good and evil. They had been a wedding present from Zeus to Hera, but Herakles secured them and gave them to Athena—the new, more powerful deification of Eve in the Greek age.

On the vase depicting Heracles entering Olympus, the seated Zeus has his back to Hera as he looks to Athena. Between them is Nike, representing their joint victory over Yahweh and his curse.

And this helps us understand the meaning of the name Herakles. It means "the glory of Hera." That doesn't make much sense unless we see that Herakles' labors chronicle the *fading* glory of Hera.

Hera remains the wife of Zeus and is still accorded honor and worship as the queen of heaven, but in the new Greek age, Athena has become the operative wisdom and power of Zeus.

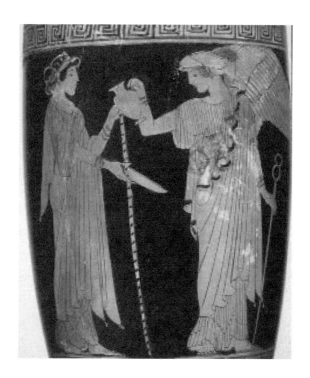

On this Attic red figure vase from ca. 480 BC, Nike pays homage to Hera. In her extended right hand, Hera holds out a phiale to receive Nike's libation. Her left hand holds her striped scepter of authority, the top of which is obscured by Nike's *oinochoe*, or wine jug. Nike's left hand holds a kerykeion indicating that she comes as a messenger of Zeus. Nike is an attribute of Zeus and Athena, and of no other deity. In this Greek age, the Victory may belong to Zeus and Athena, but due respect is still paid to the queen of the gods.

Taking Hera's Apples and Her Sphinx, Athena Supersedes Her and Becomes the Ultimate Deification of Eve

The extant metope at the northeast corner of the temple of Hephaistos in Athens still depicts Herakles presenting Athena with the three apples from the Garden of the Hesperides. The drawing fills in the figures. Herakles may as well be saying, "Here Athena, these golden apples from the serpent's tree which once belonged to Hera, now belong to you. By guiding me in all my labors you have proven that you are the one who enlightens and empowers mankind with the knowledge of good and evil, and offers the promise and hope of immortality."

Hera and Athena each had possession of the sacred fruit from the serpent's tree in the Garden at one time, sure evidence that they are both pictures of Eve.

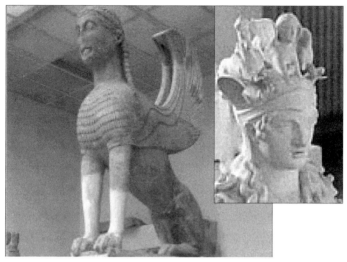

Marble sphinx from Delphi ca. 570 BC and head of Athena
Parthenos with sphinx atop her helmet from a Roman copy.

As we know from the story of Oedipus, Hera originally controlled the
sphinx, a riddle-uttering winged monster with the head of a woman and
the body of a lion. By the fifth century BC when Phidias constructed the
great statue of Athena Parthenos, the sphinx and her enigmatic power
belonged to Athena, as we know from its image atop her war helmet.
Athena's possession of the sphinx shows that her authority supersedes
that of Hera. The wings of the sphinx symbolize power in the heavens;
the body of the lion, power on earth; and the woman's head represents
the mysterious Eve, mother of all living.

Hera and Athena both represent Eve, but Eve worshipped in different
ways. Mankind originally worshipped Eve as the great mother-goddess
of childbirth and marriage. As Greek religion became systematized after
the Flood, worship focused on Eve as Athena—the embodiment of the
serpent's power and promises. In Genesis, the fruit of the tree was "good
for food," brought "a yearning to the eyes," and was "to be coveted as
the tree to make one intelligent." It is for embodying this last quality for
which Athena, as goddess of the serpent's wisdom, was specifically and
especially revered.

Chapter 6

Hephaistos—The Deified Cain

We've seen that Greek religion is a sophisticated form of ancestor worship. Now, if Zeus is the serpent transfigured into an image of Adam—the head of the race of humanity—and Hera is an image of the primal Eve, the mother of all living, who then is Hephaistos and why is he the one cracking open the head of Zeus to release Athena? Why is it even necessary? Hephaistos, a forger of weapons and armor for gods and heroes, is a deification of Cain, the first son born to Eve and, according to Genesis, the first murderer. We must remember, however, that from the point of view of those who embraced the serpent as the enlightener of mankind, Cain was a hero. Through Eve's bold choice, humanity had become liberated at last from the Creator of Eden. Cain's younger brother, Abel, endeavored to reestablish the old order through a blood sacrifice acceptable to his God, while Cain felt pressured to give up a portion of his fruit to a god he did not want running his life. Abel's attempt to reestablish a bond with the God of Genesis was to Cain a step back into bondage. Cain became enraged when he found out that

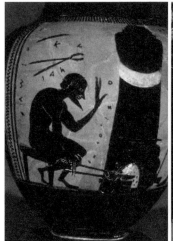

The bearded master at the foundry on the Attic black figure oino-choe (wine jug) from ca. 500 BC looks much like the figure of Hephaistos on the Attic red figure calyx krater (mixing pot) from the same period.

Abel was trying to undo the serpent's work, and so killed him.

By his Roman name, Vulcan, we associate Hephaistos, the deified Cain, immediately with the forge and the foundry. According to Genesis 4:22, the members of Cain's family were the first to become forgers "of every tool of copper and iron." These surely included the hammer and the axe, the tools most often associated with Hephaistos

Greek mythology presents Hephaistos as a cripple from birth, "the renowned lame god," although it is not explained why this is so. This lameness may well be the mark or sign mentioned in Genesis 4:15: "And placing is Yahweh Elohim a sign for Cain, to avoid anyone finding him smiting him."

Since Cain was the eldest son of Eve, we would expect Hephaistos to be the eldest son of the deified primal Eve, Hera. And, indeed, this is so. Zeus, the deified Adam, is his father. One myth suggests that Hera gave birth to Hephaistos parthenogenetically; that is, without the aid of

a male god or man. The source of that myth may be found in Genesis, for when Cain was born, Eve spoke in the first person singular, as if Cain were hers alone: "I acquire a man, Yahweh" (Genesis 4:1). Cain, *Qin* in Hebrew, means "acquired."

After the murder of Abel, Yahweh gave this command to Cain: "a rover and a wanderer shall you become in the earth" (Genesis 4:12). Cain became an outcast, but true to his antipathy toward Yahweh, Cain quickly settled in one place and built the first-ever city:

And knowing is Cain his wife and she is pregnant and bearing Enoch. And coming is it that he is building a city, and calling is he the name of the city as the name of his son, Enoch (Genesis 4:17).

When Cain settled in that city, he ceased being a wanderer and an outcast. This idea comes through in a very important Greek myth as well. Hephaistos was also an outcast for a while. One version says he was thrown out of Olympus by Hera; another version says it was Zeus who threw him out. There came a time, however, when the outcast was welcomed back as part of the established order. This is what happened to Cain. We shall encounter Cain again as Hephaistos, in the second book of the series, after the Great Flood when he is instrumental in the founding of another city—Athens.

In Plato's *Cratylus*, Sokrates says that Hephaistos means "princely lord of light." According to Robert Graves, his name is a contraction of *hemeraphaestos* which means "he who shines by day." Hephaistos shines because he is Eve's eldest son, Cain, who welcomes Zeus (the transfigured serpent) as his light, and receives the knowledge of good and evil as a boon—the moment of lighting up.

Cain, immortalized as Hephaistos, embraced the serpent's wisdom and through his offspring, systematized belief in it. His cracking open of Zeus' head released Eve's original choice to obey the serpent, and immortalized her as Athena.

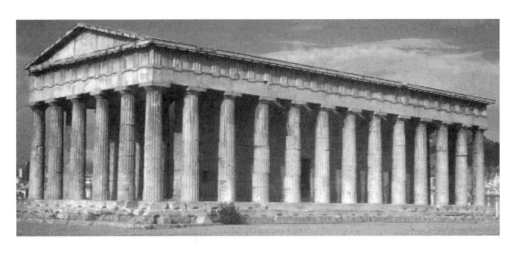

The temple of Hephaistos in Athens on the west side of the agora—the market and meeting place in the center of the city. The Greeks worshipped both Hephaistos and Athena in this temple built from 449 - 444 BC. Ironically, the temple of the "renowned lame god" survives as the least crippled temple in Greece.

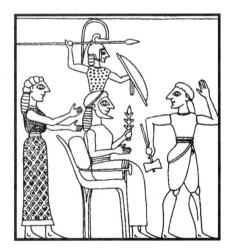

Drawing of a bronze relief on a shield band panel from Olympia ca. 550 BC depicting the birth of Athena. The lightning bolt held by Zeus associates "the moment of lighting up"—the actual meaning of the name Zeus—with the birth of Athena. With a blow of his axe, Cain, deified as Hephaistos, initiates the worship of the serpent's Eve as Athena. (Eileithyia, a sister of Hephaistos, serves as midwife).

Without Hephaistos, the Deified Cain, There is no Greek Religion

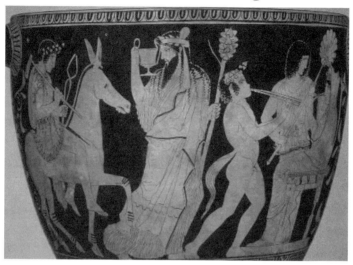

The scene on the Attic red figure *skyphos* (drinking cup) from ca. 425 BC (above, and detail on the next two pages) tells us a great deal about how the Greeks viewed Hephaistos. The vase depicts his return to Olympus. It is not clear from Greek myth exactly why he had been thrown out or whether it was Hera or Zeus who did it, but the fact that this myth appeared painted, sculpted, and bronzed throughout the Archaic and Classical periods, tells us that his return to Olympus constituted an essential element of Greek religion.

According to the myth, while in exile, Hephaistos sent a golden throne that he had made to his mother, Hera. Once she sat in it, invisible cords bound her to it. On the vase, Hera sits on this golden throne. Playing his double flute, a satyr announces the return of Hephaistos and a female attendant, holding a palmette fan, stands by Hera. A diadem, a symbol of rule, rests on Hera's head, but it is mostly covered with a hood implying that until Hephaistos returns she cannot be free to exercise this rule.

Dionysos, in the center, looks back over his shoulder directly to Hephaistos and beckons him to return with him to Olympus. He dis-

plays a *kantharos* to Hephaistos, suggesting that this wine-drinking cup symbolizes his reward, or what the scene is ultimately about, or both. Hephaistos rides a donkey, carries his hammer and tongs, and follows the lure of the kantharos held up by Dionysos.

What are we to make of this? In all my reading of Greek myths, I have never seen the return of Hephaistos to Olympus explained. That's because it cannot be explained without reference to Cain and Genesis. Keep in mind, as we review some of the early events of Genesis, that a return to Olympus by Hephaistos signifies a return to the authority of the serpent's religious system by Cain.

Now, according to Genesis, after Adam and Eve partook of the forbidden fruit, they became ashamed and repented. They then accepted God's provision as a sign of accepting his authority: "And making is Yahweh Elohim for Adam and for his wife tunics of skin, and is clothing them" (Genesis 3:21).

Abel, their youngest son, accepted Yahweh's authority also, but Cain, their eldest, did not. He killed Abel and then defied God's command to wander through the earth as punishment. Cain built a city, settled there, and passed on his defiance to his offspring. From the point of view of Scripture, Cain was "of the wicked one," and "the way of Cain" became a description of behavior opposed to the will and worship of Yahweh Elohim.

Cain's rejection of Yahweh was total. We see this in the names of Cain's immediate offspring. The name of his son, Enoch, means "dedicated," presumably to the ways of his father; the name of his grandson, Irad, means "city suffices;" and the name of his great-grandson, Mehujael, means "wipe out God." When the story of Cain's banishment makes its way into Greek myth, Yahweh no longer even plays a part in it.

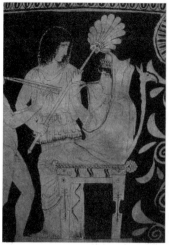

While Adam and Eve's repentance, to a great degree, had negated the serpent's work, Cain's continuous rejection of Yahweh's ways renewed the serpent's power, and made a virtue of what Eve had done at the serpent's behest. Those who embraced the way of Cain began to idolize Eve's willingness to obey the serpent. From their perspective, Eve's taking of the fruit was the most significant and positive event in the history of humanity. Thus Cain and his line systematized the rejection of Yahweh and set the serpent's wisdom free, ultimately enabling the worship of Cain's mother, Eve, as the queen of the gods. This is the very message that our vase so succinctly portrays.

We see Hera seated on the throne given to her by her son Hephaistos. This gift, in itself, shows that Hephaistos (Cain) is in the process of making his mother Hera (Eve) humanity's queen. On the vase, she is poised to rule, but is unable as yet to exercise her authority. Two things had to happen before Hera could take her place as the deified Eve and queen of the gods: first, the God who planted the Garden had to be rejected; and second, what Eve did in the Garden—the taking of the fruit making possible the knowledge of good and evil—had to be revered and glorified. Cain and his offspring fulfilled both requirements. And here, on his donkey, comes Hephaistos, the deified Cain, suggesting just that.

In our scene, Hephaistos *is* returning and the hood that symbolizes the covering of Hera's rule *is* receding. We can picture the scene before Hephaistos begins his return—the hood completely covering her crown. And we can picture the scene after the return of Hephaistos is accomplished—Hera's hood shed, her crown glistening, the invisible bonds loosed, and her rule over a large segment of humanity begun.

The vase shows that it is the promise of the kantharos which entices

Hephaistos to return. On one level, it is a symbol of a pleasurable wine-drinking time. But there is a much deeper significance to it. The word kantharos itself means "dung beetle." This religious symbolism comes from Egypt where the dung beetle, or scarab, signifies transformation and immortality. The kantharos here represents the serpent's promise of immortality: "Not to die shall you be dying . . . in the day you eat of [the tree] unclosed shall be your eyes, and you shall become as gods, knowing good and evil."

When Cain defied Yahweh's command to become a rover and a wanderer in the earth, and established instead a city, he figuratively returned to Olympus—to the realm of Zeus the transfigured serpent—and as his reward, he became immortalized as Hephaistos.

We have seen that both Hera and Athena are pictures of the serpent's Eve. Hera is the primal Eve, wife and sister of Zeus, and goddess of childbirth and marriage. Athena is the picture of the more sophisticated Eve, the goddess of the serpent's wisdom, a goddess capable of establishing the rudiments of humanity's central culture in this age, and a goddess capable of ruling the collective mind of that entire culture. It is Hephaistos, the deified Cain, who allows both of these goddesses to take their places of rule, at their respective times. His role in Greek religion is more than important and basic, it is essential. The myth of his return to Olympus and his role in the myth of Athena's birth say so in no uncertain terms: Hera remains bound to her golden throne and cannot rule unless Hephaistos returns to Olympus to release her; and Athena, the sophisticated image of Eve, cannot emerge from the mind of Zeus and rule this Greek age unless Hephaistos sets her free with a blow of his axe.

In sum, without Hephaistos, without Cain and his way, there is no Greek religion.

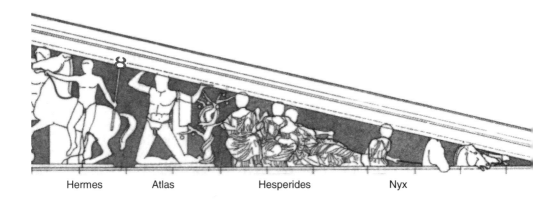

Hermes Atlas Hesperides Nyx

Chapter 7

Nyx—The Darkness Out of Which Arose Paradise

Zeus' birthing of Athena is the centerpiece of the east pediment; however, that event is not the beginning of the Greeks' figurative account of their origins. Hesiod traces the beginning of the Greek cosmos, or world-system, back to something he calls Chaos. Chaos is not portrayed on the pediment but it is implied for out of Chaos, according to Hesiod, came Nyx, or Darkness, and Nyx is portrayed departing in her four-horse chariot in the right corner of the triangular panorama. Phidias, the chief sculptor, is showing us how, out of Chaos through Darkness (Nyx), order emerged in the Greek view of their world-system.

Hesiod's account of creation does not reach back beyond Chaos to the "Created by God [Elohim] were the heavens and the earth" in Gene-

sis, but begins with Chaos itself, out of which emerged Nyx or Darkness. Out of Nyx emerged the Hesperides, nymphs of the West representing a luxurious and carefree garden, and the Three Fates representing death. According to Hesiod, the Fates "give men at their birth both evil and good to have." Thus, just as in Genesis, the knowledge of good and evil is associated with the beginning of the experience of death for humanity.

On the pediment, Nyx is departing. She leaves behind the Hesperides who appear next to her on the pediment and the Three Fates who appear in a corresponding spot on the opposite side of the pediment, setting the stage for the Earth-shaking drama in the center—Eve's taking the fruit from the tree of the knowledge of good and evil, her figurative birth from the head of the transfigured serpent.

As we see from the comparisons on pages 80 and 81, Greek myth and Genesis tell essentially the same story, including the Flood. The major difference in the Greek version is that Yahweh is either left out (as the original Creator) or replaced by Zeus (as initiator of the Flood).

The east pediment sculptures are narrative art: they tell a story. Nyx tells us when the crucial event—the taking of the fruit—took place. Nyx is departing, so our scene is set after her departure, at the time the Garden of the Hesperides existed, and more specifically, at the time the Three Fates, representing death, came into being.

Figure N (left) is the torso of the charioteer Nyx, representing Night or Darkness. Figure O (above) is the outer horse of the four-horse chariot belonging to Nyx.

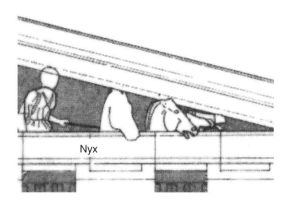

Many Parthenon scholars are undecided whether Figure N and her horses in the right corner of the east pediment represent Selene (the Moon), or Nyx (Night or Darkness). From an astronomical point of view, Kristian Jeppesen has explained why it cannot be Selene. He writes in his "Evidence for the Restoration of the East Pediment Reconsidered in the Light of Recent Achievements," a contribution to the *Parthenon Kongress*:

Strictly speaking, Selene sinking at the same time as Helios is rising [on the pediment's far left] implies that the moon is in direct opposition to the Sun and therefore full. However, this happens only in the middle of the [lunar] month, while according to ancient sources the birth of Athena took place on the 3rd or on the 28th of the month, that is, either when the new moon had just begun to increase or when the waning moon had nearly disappeared. On both days, the moon was seen at a distance of only some 20 or 30 degrees from the Sun. If, therefore, the birth is supposed to have taken place on one of these days, figure N must logically be assumed to represent Nyx rather than Selene.

There is an even better reason that this is not Selene, but rather Nyx. According to Hesiod, Chaos was the beginning of the Greek cosmos, or world-system, and Nyx came out of Chaos. Out of Nyx came the Hesperides and the Three Fates, and both of these groupings are found sculpted on the east pediment, and they relate directly to the birth of Athena.

Greek Myth . . .

Hesiod, *Theogony*

In truth at first Chaos came to be . . .

From Chaos came forth Erebus (the covered pit) and black Night (Nyx) . . .

And again the goddess murky Night [Nyx], though she lay with none, bare . . . the Hesperides who guard the rich, golden apples and the trees bearing fruit beyond glorious Ocean.

Also [Nyx] bore the Destinies and ruthless avenging Fates, Clotho and Lachesis and Atropos, who give men at their birth both evil and good to have.

Apollodorus

[The apples of the Hesperides] were presented by Earth to Zeus after his marriage with Hera, and were guarded by an immortal dragon.

And when Zeus would destroy the men of the Bronze Age, Deucalion by the advice of Prometheus constructed a chest, and having stored it with provisions he embarked in it with Pyrrha. But Zeus by pouring heavy rain from heaven flooded the greater part of Greece, so that all men were destroyed, except a few who fled to the high mountains in the neighborhood. It was then that the mountains in Thessaly parted, and that all the world outside the Isthmus and Peloponnese was overwhelmed. But Deucalion, floating in the chest over the sea for nine days and as many nights, drifted to Parnassus, and there, when the rain ceased, he landed and sacrificed to Zeus, the god of Escape.

. . . Compared to Genesis

Genesis

Created by God [Elohim] were the heavens and the earth.

Yet the earth became a chaos and vacant . . .

And darkness was on the surface of the submerged chaos.

And planting is Yahweh Elohim [the Lord God] a garden in Eden . . . sprouting is Yahweh Elohim from the ground every tree coveted by the sight and good for food, . . . and the tree of the knowledge of good and evil . . .

. . . "Yet from the tree of the knowledge of good and evil, you are not to be eating from it, for in the day you eat from it, to die shall you be dying."

And taking is [Eve at the serpent's urging] of its fruit and is eating, and she is giving, moreover, to her husband with her, and they are eating.

"Wipe will I the humanity, which I have created, off the surface of the ground . . . for I regret that I have made them." . . . And coming is it . . . that the waters of the deluge come to be on the earth . . . On this day rent are all the springs of the vast submerged chaos, and the crevices of the heavens are opened, and coming is the downpour on the earth forty days and forty nights . . . And having the mastery are the waters and they are increasing exceedingly on the earth, and going is the ark on the surface of the water . . . And abating are the waters . . . And forth is faring Noah [from the ark], and his sons, and his wife, and his sons' wives with him . . . And building is Noah an altar to Yahweh Elohim . . .

Greek and Hebrew Post-Creation Stories Match

The parallelism of the Greeks' account of the origin of the cosmos with that of Genesis has been obscured for centuries by mistranslations in the King James Version. One mistranslation obscures the fact that Nyx, or Darkness came out of Chaos—just as the Greeks said. Verses one and two of chapter one of Genesis in the King James Version read:

In the beginning God created the heaven and the earth.
And the earth was without form, and void; and darkness was upon the face of the deep. And the Spirit of God moved upon the face of the waters.

Common sense tells us that there is something very wrong with this translation. Try to picture an earth without form. If you are an artist or have an artist friend, ask him or her to draw you a sketch of an earth without form or an earth that is void. You can't picture it and you can't sketch it because it doesn't make any sense. The Concordant translation of those same verses of Genesis clears up the problem:

Created by God [Elohim] were the heavens and the earth.
Yet the earth became a chaos and vacant, and darkness was on the surface of the submerged chaos. Yet the spirit of the Elohim is vibrating over the surface of the water.

We can picture an earth that *became* a chaos and vacant, and we can even sketch such an earth, and most importantly, that translation agrees with the original Hebrew.*
The Concordant rendering of Isaiah 45:18 also shows that God did not create the earth "without form and void":

For thus says Yahweh, Creator of the heavens,
He is the Elohim, and Former of the earth, and its Maker,
And He, He established it.
He did not create it a chaos.
He formed it to be indwelt.

*If the Hebrew verb were *eue*, was would be an accurate translation; but it is *eie*, the causative form of be which means become. This causative form (*eie*) appears more than twenty times in chapter one of Genesis alone, and everywhere denotes a change, and not mere existence. (This analysis is the work of A. E. Knoch).

Then ten times in the New Testament, the King James Version mistranslates the Greek word *katabole* as foundation. *Kata* means down, and it comes into English in such words as cataclysm and catastrophe. *Bole* means casting or throwing. Together they mean down-casting. The whole word comes into English as catabolism which means "the breaking down of complex bodies." Katabole is in reality a disruption and is translated that way throughout the accurate and consistent *Concordant Literal New Testament*. The New Testament verses which contain the word katabole refer directly to the disruption which caused the chaos after the initial creation.

Thus, according to Scripture, Yahweh is not said to have created the original earth in six days, but rather He is said to have *restored* the disrupted and chaotic earth in that time frame, be it literal or figurative.

The point is that when we compare the original texts, we find important connections between the Hebrew and Greek accounts of the origin of things. Hesiod says out of Chaos came Nyx, or Darkness. A true rendering of Genesis 1:2 says basically the same thing: the earth became a chaos, and then there was darkness on the surface of that chaos.

Out of the darkness, Yahweh made light, restored the chaotic earth, and created Eden and Adam and Eve; then death became a part of the human experience. Leaving Yahweh out of the picture, Hesiod says essentially the same thing: out of Chaos came Darkness (Nyx); out of Nyx came the Hesperides (a collective iconograph representing paradise) and then the Three Fates who administer death to humanity.

When we break it down to the basics, we see how very close is the order of events in the two accounts. Genesis says that God creates all, then:

Chaos-Darkness-Paradise-Death-Flood

The Greek account leaves out the Creator but the rest is the same:

Chaos-Darkness-Paradise-Death-Flood

The collective cultural memory of the Greeks as to the main events following creation thus matches what is written in the Sacred Scrolls of the Hebrews. It's the same story.

Chapter 8

The Hesperides—A Picture of Paradise

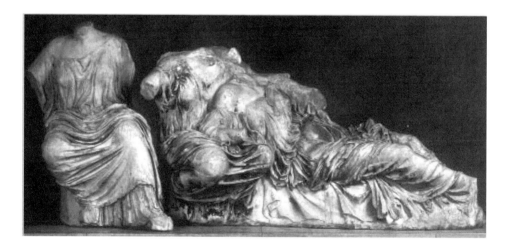

When we look at Figures K-L-M in the British Museum and at Peter Connolly's reconstruction on the next page, we notice that none of them is reacting to the birth of Athena. So then in what way do they relate to it? Their function is to show us where Athena, the deified Eve, was born and where the Greek religious system originated . . .

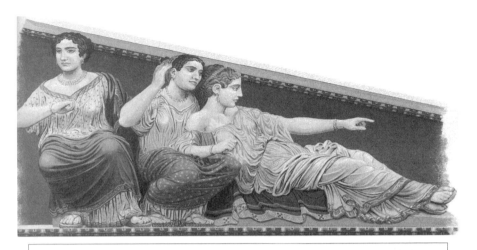

. . . These are three Hesperides, nymphs of the West, whose presence in Greek art is always associated with their garden and a tree with a serpent coiled around it. Their posture suggests a luxurious setting and a state of continuous enchantment and bliss. The Hesperides form a collective iconograph which depicts paradise—the Garden of Eden.

Throughout ancient Greek art, we find an apple tree with three golden apples and a serpent wrapped around its trunk. We think of Eden, and rightly so. The spirit-beings associated with this tree and its apples are called Hesperides, a name which means "nymphs of the West." *Hespere* means evening, and that of course signifies the West where the sun sets. This accords with the Genesis account which describes civilization developing to the east of Eden. A trek back to the Garden would necessitate traveling west. The Greeks put the Garden of the Hesperides in the Far West.

The existence of the Garden and the idea of Herakles obtaining the three apples from its serpent-entwined tree and presenting them to Athena is extremely important in Greek iconography. Depictions of it appear on a metope over the entrance to the temple of Zeus at Olympia, inside Zeus' temple on a painting, sculpted next to an image of Athena

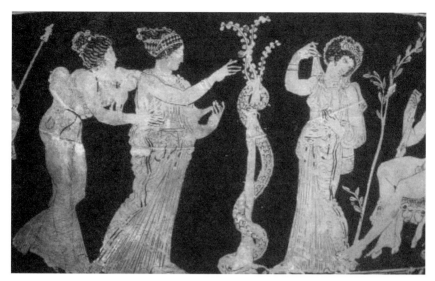

The Garden of the Hesperides. On this Attic red figure *hydria* (water pot) from ca. 410 BC, the Hesperid to our right of the serpent and the tree holds the golden apples in the folds of her cloak. Next to her, we see half of a seated Herakles.

in Hera's temple at Olympia, carved therein on the cedar wood chest of Kypselos, on a metope on the temple of Hephaistos in Athens, and on numerous red and black figure vases from the Archaic and Classical periods. We certainly should expect to see this subject represented in a very prominent way on the Parthenon. The only place where its depiction would make sense and there is sculptural evidence for it is the east pediment.

As far as I know, the first person to identify Figures K-L-M as Hesperides was Kristian Jeppesen at the Parthenon Kongress in Basel in 1982. He writes of Figures K-L-M: "Apparently they are not involved in any kind of willful action, but seem to display some slight amazement at being disturbed in the act of performing their morning toilet. This situation agrees perfectly with representations of the Hesperides on vases, where they are always depicted as lovely fairies with little other

concern than the preservation of their beauty."

But why are they depicted like that? Reference to the Garden of Eden gives us the answer. Eden is derived from the Hebrew word *âdan* which, according to *The New Strong's Exhaustive Concordance of the Bible* means "to be soft or pleasant," figuratively: "to live voluptuously, to delight oneself." This is precisely the mood the Greek painters and sculptors suggest. The Hesperides are guardians of the tree only in the sense that they are always pictured with it. Their body language and easy actions establish what kind of a garden this is: a wonderful, carefree place. It is the original paradise. And no, the Greeks did not borrow a copy of Genesis from the Jews to come up with this: it was rather part of the Greek collective cultural memory, just as was the case with most of the rest of their religion. They knew that their original ancestors came from a place like this.

We have seen that Eve was the "mother of all living" and the first woman to marry, and that Hera, worshipped as the goddess of childbirth and marriage, was a deification of Eve in these aspects. According to Greek myth, the golden apples originally belonged to Hera. They had been a wedding present to her from Gaia (Earth) or directly from Zeus who had considered them his most precious possession. So how did Athena get the apples and what did that signify? To answer that, we need to go into more detail about the relation of Herakles to Hera, Athena, and the golden apples of the Hesperides.

Most schoolchildren have heard of the mighty Herakles and his twelve labors. Films and television series about him using his Roman name, Hercules, have attracted great popularity. What is almost always missed in the recounting of his adventures is that within them, we find the story of the transfer of power from Hera to Athena.

From the first of his labors to the last, Hera opposed Herakles while Athena assisted him. That fact alone should cause us to suspect that the successful completion of Herakles' labors would accrue to the detriment of Hera and the benefit of Athena.

On this Attic red figure hydria from ca. 465 BC, Herakles, wearing his familiar lion-skin headdress, makes off with the three golden apples of the Hesperides. They have no power to stop him; their presence simply identifies the scene as paradise. Note that the serpent wears a beard, a symbol of age. The Book of Revelation refers to God's Adversary as "the *ancient* serpent."

Above: four Hesperides at a fountain with the apple tree and serpent, from an Attic red figure *pyxis* (round cosmetic box), ca. 460 BC. The number of the Hesperides varies in pictorial art and literature. Hesiod mentions three. There were five carved on a chest in the temple of Hera at Olympia. On Attic vases there are most often three, more rarely two or four, and on one Apulian vase, seven. The requirements of the composition determined the number of Hesperides chosen. Recent technical evidence gleaned from the pediment and sculptures indicates that there was one, and possibly two more figures behind K-L-M. While the identification of K-L-M as Hesperides does not need strengthening, this discovery does just that.

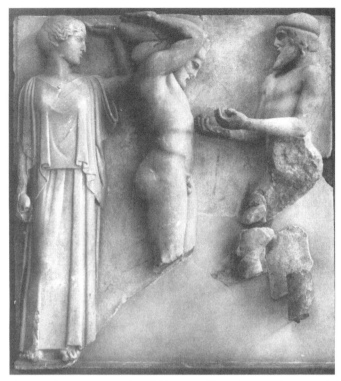

Metope from the temple of Zeus at Olympia, ca. 457 BC. Atlas presents the apples of the Hesperides to Herakles who temporarily upholds the heavens, with Athena's help, in his place. The apples once belonged to Hera, but now Herakles will give them to Athena initiating her rule of the Greek age in which we live.

The climax comes in the twelfth labor where Herakles is charged by his mentor, King Eurystheus, to bring to him the golden apples of the Hesperides. The Garden of the Hesperides turned out to be just beyond the place where Atlas stood pushing up the heavens, and the location of the Garden was a secret known only to him. Herakles talked Atlas into procuring the golden apples for him. This Atlas did while Herakles temporarily took his place as the elevator of the heavens, with Athena's help. When Atlas returned with the apples, Herakles headed back eastward with them. In his *The Meridian Handbook of Classical Mythology*, Edward Tripp concludes the story:

Close-up of Herakles. The hero is able to push away the heavens, and with them the God of the heavens. He has earned the right to receive the sacred fruit.

Herakles . . . took the apples to Eurystheus at Tiryns without further interruptions. Eurystheus quickly returned them to Herakles, who as quickly turned them over to Athena, presumably by dedicating them at her shrine. Athena gave them back to their original guardians, the Hesperides, for it was not proper that the sacred fruit should remain in anyone else's keeping.

The sacred fruit were back where they belonged—in the Garden. But the golden apples had changed hands. Originally the apples were a wedding present from Zeus to Hera, from the serpent to Eve. They still belonged to Eve, but not the primal Eve deified as a goddess of marriage and childbirth, but the sophisticated Eve of the new, postdiluvian age deified as Athena—the goddess destined to grant her worshipers the intelligence and wisdom of the serpent in this age which the apostle Paul, in I Corinthians 4:3, refers to as "man's day."

The story of the Hesperides and the golden apples can't be told without reference to Atlas and Herakles. We should find both of them depicted on the east pediment. And we do.

Nyx . . . Bare . . . the Hesperides who guard the rich, golden apples and the trees bearing fruit beyond glorious Ocean.

Hesiod, *Theogony*

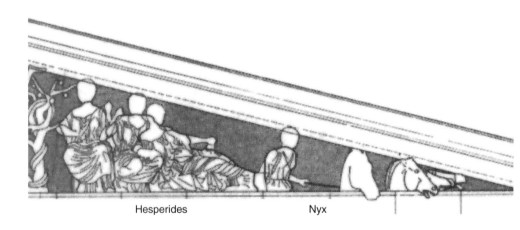

Hesperides Nyx

On the restoration (from right to left) of Nyx, the Hesperides, and the serpent-encoiled tree, above, the Hesperides occupy cornice blocks 20, 21, and 22. In Greek art, they are always represented with the tree, and it must have appeared on cornice block 19, to their proper right, our left. This particular block was replaced in Roman times and bears no traces of the sculptures it carried. As Kristian Jeppesen has pointed out, if the attribution of the marble fragments traditionally ascribed to Athena's olive tree in the west pediment holds true, the tree of the Hesperides—the tree of the knowledge of good and evil—is also likely to have been sculpted in marble.

Chapter 9

Atlas Pushes away the Heavens, and with Them, the God of the Heavens

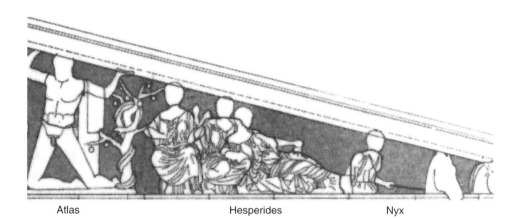

Atlas Hesperides Nyx

Above: drawing of Atlas, the Hesperides, and Nyx. As Nyx departs the scene, she leaves behind her offspring, the Hesperides, always depicted in Greek art with the serpent-entwined tree. Next to them, we find Atlas, for according to Hesiod, Zeus himself has placed him there, standing "at the borders of the earth before the clear-voiced Hesperides." The raking cornice represents the skyline or heaven. By lifting here, Atlas enables Zeus, the transfigured serpent, to stand at the apex of the triangle—the center of Greek religion.

The muscular torso called Figure H discovered beneath the east front of the Parthenon in 1836.

When Ludwig Ross dug around the foundations of the Parthenon in 1836, he found, among other fragments of sculptures lying beneath the east front, only one piece which in his opinion might possibly have fallen from the pediment: a male torso preserved from neck and shoulders to the hips. Because of the find-spot, the heavy weathering, and indications on the neck that the head was turned a little to the right, the torso is commonly attributed to the right side of the east pediment.

The muscular tension [of the sculpture known as Figure H] springs from great physical effort: both arms are raised, the left hip is placed higher, the neck turns to its proper right. The comparatively small scale of the statue necessitates its placement far from the center and therefore at some distance from Zeus.

From the writings of Olga Palagia and Kristian Jeppesen

Experts from the Institute of Anatomy at the University of Aarhus in Denmark helped Kristian Jeppesen with this technical anatomical analysis of the torso known as Figure H: "The right arm is raised a little more than the left one, as shown by the deltoid muscle. The poise of the head is stooping. The right thigh is almost on a line with the side of the body, while the direction of the left thigh deviates markedly from the axis of the trunk, as indicated by the swelling musculus obliquus externus abdominis on the left side of the torso. That the muscles of the right arm were more tensely activated than those of the left arm is confirmed by the contraction of the trapezoid muscle on the right side of the spine. The sharp dividing line separating the upper and lower musculus rectus abdominis and the deep linia semilunaris on the lower abdomen are obvious signs of physical exertion that cause the lungs to gasp for breath. The contraction of the shoulder blades seems excessive but actually corresponds to an intermediate position." Above: a live model trained in body building poses in an attitude comparable to that of the restored torso.

Atlas is a picture of Adam prior to his eating the fruit—and of mankind in general

Atlas presents us with a picture, from the Greek point of view, of Adam in the Garden of Eden just prior to his eating of the forbidden fruit. Before he could eat of the tree of the knowledge of good and evil, Adam had to put God and the strict spirituality of His law at a distance. In that sense he became the "elevator of the heavens," enabling himself to feel as if heaven were afar off from earth, and to act as if the God of the heavens could not see through the clouds, or did not regard with displeasure one who would flout His instructions.

According to Robert Graves, Atlas means "he who dares," or "he who suffers." Both definitions point to Adam since by eating the forbidden fruit, he was one who dared and as a consequence, became one who suffered. But Atlas is more than simply a picture of Adam: he represents Greek humanity as a whole making room for the gods they believe they are choosing to worship.

Greek religion is the system of Zeus—the transfigured serpent. Athena is the serpent's Eve and goddess of its wisdom. The Supreme God of the heavens has no place in this system. For Greek religion to prosper, mankind must keep pushing the heavens and the God of the heavens away. And the Greeks kept pushing until they lost the knowledge of What they were pushing away and why they were doing it. This is memorialized in this previously cited passage from the Book of Acts:

Now Paul, standing in the center of the Areopagus [the Hill of Ares west of the Akropolis], averred, "Men! Athenians! On all sides am I beholding how unusually religious you are. For, passing through and contemplating the objects of your veneration, I found a pedestal also, on which had been inscribed, 'To an Unknowable God.' " (Acts 17:22-23).

It isn't that Greek religion excoriates the Creator, or makes Him into a hated "other," but rather that Zeus, Athena, and the rest of the gods obscure His memory and take His place.

> **And Atlas through hard constraint upholds the wide heaven with unwearying head and arms, standing at the borders of the earth before the clear-voiced Hesperides; for this lot wise Zeus assigned to him.**
>
> **Hesiod, *Theogony***

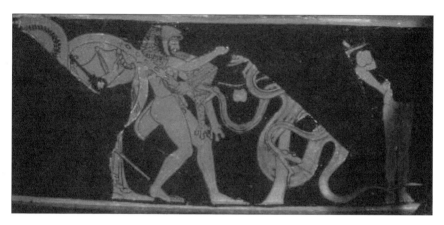

Above: a section of a damaged Attic red figure vase, ca. 490 BC, with part of a scene in the Garden of the Hesperides. We can make out Herakles, most of the serpent, about half the tree, and half of the muscular body of Atlas as he elevates the heavens.

Nyx, the Hesperides, and Atlas share an intimate association in Greek myth. In the Far West of the world, Atlas stands before the "clear-voiced Hesperides" who originated in Nyx. We've seen that the greatest of Greek heroes, Herakles, also had an intimate connection to the Hesperides and Atlas. In chapter twelve, we'll examine that connection in more detail and Herakles' special place on the left side of the east pediment. But first we'll take a look at how the chief sculptor, Phidias, used Hermes to connect this background scene on the right side with the scene of Athena's birth in the center.

97

Chapter 10

Hermes—The Deified Cush Connects Eden with the Rebirth of the Serpent's Eve

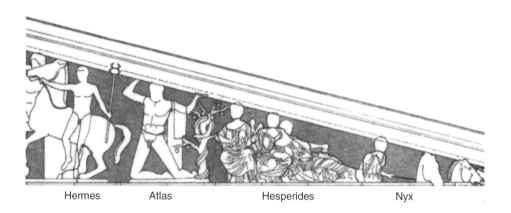

| Hermes | Atlas | Hesperides | Nyx |

The right side of the east pediment explains the background of Athena's birth. Moving from the right corner toward the center: first, there was Darkness (Nyx) and out of it came paradise (the Hesperides, the tree, and serpent); then mankind (Atlas) pushed away the heavens and with it, the God of the heavens, so that humans might become as gods knowing good and evil.

But then came the Great Flood with all of humanity wiped out save the family of righteous (Yahweh-believing) Noah. The Greeks sculpted their interpretation of this event on the west pediment of the Parthenon (This is a subject of the second book in the series). In the succeeding

generations, Noah's grandson Cush, deified by the Greeks as Hermes, reconnected a large portion of humanity to the serpent's enlightenment and promises from the time of the Garden of Eden. As such, Cush took a preeminent place in the postdiluvian world, and ultimately in the Greek religious system as Hermes. According to L. H. Martin, he was the "implementer of Zeus' will, or that of the celestial Olympians collectively, among the inhabited world."

On the east pediment, Hermes undoubtedly carried his kerykeion, or staff with a two-headed serpent. One head looked to the past while the other looked to the future.

Hermes, like many of the gods in the Greek pantheon, was the deification of a dead human being. He is Cush, the son of Ham, and the grandson of Noah. Cush was the man who founded Babylon, and led the effort to unite humanity—without Yahweh—in the building of the infamous tower there. Cush, or Hermes, was the great soothsayer and prophet worshipped in Babylon. Pausanias wrote that he was referred to as Hermes *Agetor*, meaning "leader of men."

The Greeks recognized Hermes as the author of their religious rites, and the interpreter of the gods. They understood him to be the grand agent in that movement which produced the division of tongues—they called him the "divider of the speeches of men." According to Plato, Hermes invented language and speech. Hermes in Greek means *translator*. From Hermes, we derive our word hermeneutics which is the science or art of language interpretation. This points us directly to Babylon and the tower of Babel, where the tongues of mankind were divided, and from then on, an interpreter or translator was required.

In Hermes' Greek genealogy, we find his qualifications to promote the serpent's system. His father was Zeus and his mother was Maia. Being "fathered" by Zeus meant that he sought after and welcomed the serpent's wisdom and promises. Maia's father was Atlas, the man who pushed away the heavens, and with them, the God of the heavens. Fathered by the transfigured serpent and descended on his mother's side

from an archtypal man who pushed away the God of Eden, Hermes had excellent credentials for the job of chief messenger of Zeus.

He was also Hermes *Psychopompus*, literally "the conductor of souls" who led humans to the underworld after death. The realm of the dead is the realm of the past, and Hermes was Greek humanity's link with their past. As the god of boundaries, he was naturally able to cross what was for humans the biggest boundary of them all. Zeus had accorded only to Hermes of all the gods, free access to all three worlds—Olympus, Earth, and the Underworld. Thus Hermes, the deified Cush, was the link between the Greek present, humanity's past, and the deified ancestors of the Greek pantheon.

A herm, like the one pictured on this page, was a rectangular column with a head of the god Hermes at the top and a phallus halfway up. These ubiquitous sculptures stood upon the thresholds of homes and estates, at the gateways of towns and cities, before temples and gymnasia, at crossroads, along the side of roadways, at the frontiers of territories and upon tombs. The phallus here was not a sexual symbol, but rather an attestation of human seed, of source, of generation, and of origins. The message of the phallus: Greek religion, the basis of their civilization, issued forth from Hermes. The most famous herm was carved by Alkamenes and stood at the entrance to the Akropolis where the sacred precinct began. Pausanias wrote that there was a wooden herm in a temple on the Akropolis dedicated to Hermes by Kekrops, the serpent-man who brought Zeus-religion to Athens. Both of these Herms pointed to the fact that the religious rites performed on the sacred rock of Athens owed their origin to Hermes, the deified Cush.

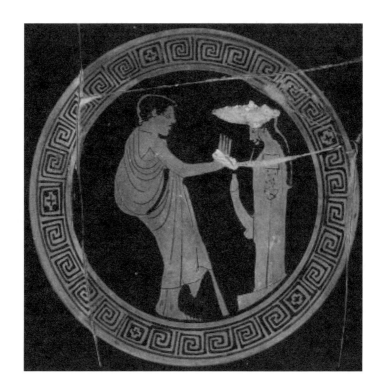

On the interior of this Attic red figure *kylix* (broad, two-handled cup) from ca. 460 BC, a youth is depicted adoring a herm. He is hunched over a bit, leaning on his staff, and has extended his right arm toward the herm, palm outward. The herm stands on a low base and is represented with very long hair, a long beard, sideburns, a mustache, and a phallus nearly one-third his height. The painting is not pornographic and is not even intended to be erotic. The significance of the phallus is that Zeus-religion figuratively owes its structure and origin to the seed of Hermes, the deified Cush from Babylon.

A Greek Vase Painter Gives Us a Concise Picture of What Happened Several Generations After the Flood

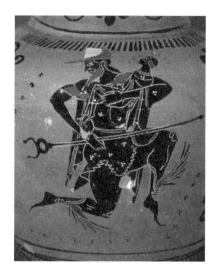

On one side of this Attic black figure neck amphora, above, from ca. 500 BC, we see Hermes flying away from the centaur Chiron on the other side. Hermes carries the infant Herakles in his left arm and holds his kerykeion in his right hand, looking anxiously back over his shoulder. The infant Herakles is wrapped in a mantle and wears a fillet in his hair. Both figures are labeled. As we shall see, Herakles is Nimrod, the great hunter and warrior from Genesis transplanted to a Greek background. Hermes is a deification of Cush, Nimrod's father. So what is really happening here? The artist presents us with a history lesson. The centaur Chiron represents Noah and his line just prior to the Flood and for an extended period after it. Cush flees with Nimrod from the authority of Noah to establish Zeus-religion. The authority of the serpent and its promises to humanity draw Hermes and Herakles away. The centaur Chiron is depicted as a creature having the rear portion of a horse and the forelegs and torso of a human. The head and face of Chiron are human and bearded, a sign of age and wisdom, but with the addition of

103

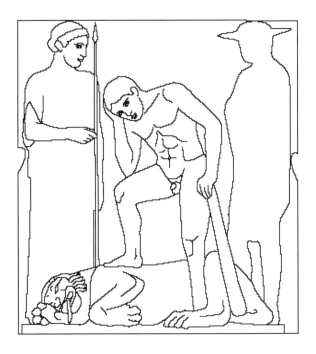

horse ears. Over his left shoulder, he carries a branch, a regular attribute, which identifies him as the source of all the branches of humanity. His hunting catch, two birds and two rabbits, hangs from his branch. Chiron's pose and gesture with his right hand suggest a combination of consternation and sadness at Hermes' departure. A dog accompanies the centaur, standing behind him.

One might object that in Greek myth Zeus, not Hermes, is the father of Herakles. But Zeus' fathering of Herakles and the rest of his children is not literal but figurative, signifying their entrance into his religious system. The father of Hermes and Athena is Zeus as well. Above, we see Athena, Herakles, and Hermes in a drawing of a metope from the temple of Zeus at Olympia depicting the first labor of Herakles—the killing of the Nemean lion. Zeus is the spiritual father of Athena (Eve), Hermes (Cush), and Herakles (Nimrod). They are not really brother and sister—all three are figuratively children of the transfigured serpent, each playing a key part in the Greek religious system.

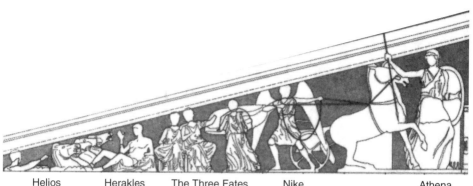

| Helios | Herakles | The Three Fates | Nike | | Athena |

Chapter 11

Helios—The Rising Sun Heralds the Birth of Athena and the New Greek Age

The remnants of Helios and two of his four horses in the British Museum, London.

As [Helios] rides in his chariot, he shines upon men and deathless gods, and piercingly he gazes with his eyes from his golden helmet. Bright rays beam dazzlingly from him, and his bright locks streaming from the temples of his head gracefully enclose his far-seen face: a rich, fine-spun garment glows upon his body and flutters in the wind: and stallions carry him. Then, when he has stayed his golden-yoked chariot and horses, he rests there upon the highest point of heaven, until he marvelously drives them down again through heaven to Ocean.

From the Homeric *Hymn to Helios*

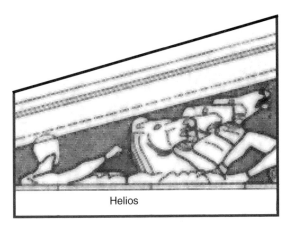

Helios

Homer's *Hymn to Helios*, above, describes the god generally for us while Homer's *Hymn to Pallas Athen*a, opposite, puts Helios right there at Athena's birth. This information is very helpful since Pausanias has told us that "all the figures . . . relate to the birth of Athena." How so with the personification of the sun? Helios stops "his swift-footed horses a long while" until Athena is able to shed her armor, signifying that the battle is over and her victory is complete. Notice how the surviving horse-head rears back as if stopping—as if depicting that very passage from Homer. Helios shines toward the center of the pediment showing Athena's birth, a birth presaging a new and bright day for mankind, a new and bright age—the age in which we live.

I begin to sing of Pallas Athena, the glorious goddess, bright-eyed, inventive, unbending of heart, pure virgin, saviour of cities, courageous, Tritogeneia. Wise Zeus himself bare her from his awful head, arrayed in warlike arms of flashing gold, and awe seized all the gods as they gazed. But Athena sprang quickly from the immortal head and stood before Zeus who holds the aegis, shaking a sharp spear: great Olympus began to reel horribly at the might of the bright-eyed goddess, and earth round about cried fearfully, and the sea was moved and tossed with dark waves, while foam burst forth suddenly: the bright Son of Hyperion [Helios] stopped his swift-footed horses a long while, until the maiden Pallas Athena had stripped the heavenly armour from her immortal shoulders. And wise Zeus was glad.

From the Homeric *Hymn to Pallas Athene*

Helios steers the solar chariot in this 5th-century BC red figure vase painting. The young boys leaping before him represent the stars fading in the light of day.

Fragment from an Attic red figure hydria ca. 440 BC with the name Helios written in Greek between the sun and his head.

On this Attic votive relief from ca. 340 BC, we see Helios, the personification of the sun, riding his quadriga. We can see four pairs of horses' back legs, and we can easily identify Helios by the solar disk on the relief surface behind his head.

Chapter 12

The Immortal Herakles—Nimrod Transplanted to Greek Soil

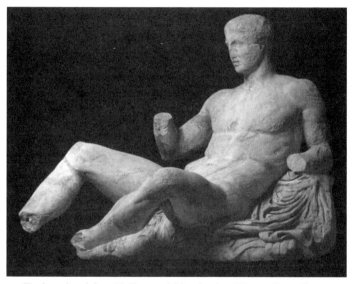

Facing the rising Helios and his chariot, Figure D reclines on a rock which most likely represents Mount Olympus. He is relaxed, naked, youthful, and of a powerful physique.

Figure D is the immortal Herakles. He reclines in the position of one enjoying a feast on a rock, suggesting pleasure on Mount Olympus. A feline pelt is spread over the rock, undoubtedly his lion skin. The fact that it is under him and not worn by him, indicates his labors are complete. He most likely held his club in his right hand and a kantharos, a wine-drinking vessel symbolizing immortality, in his left. He appears youthful because as a reward for his service to Zeus and Athena, he has received Hebe, the goddess of youth, as his wife.

Herakles Shares the Light of Helios

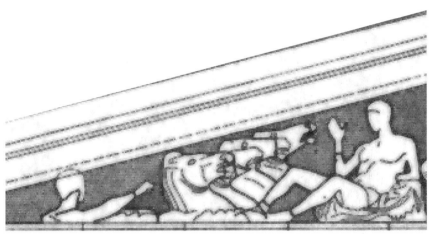

Helios Herakles

Helios, the bright sun, rises to shine on a new age ruled by Athena who at the moment of her birth emerged full-grown and fully-armed from the head of Zeus. The Greek sculptors positioned the immortal Herakles so that he might bathe in the bright light from Helios also. Herakles is the Greek counterpart of Nimrod, the great benefactor of humanity in Genesis who reestablished the way of Cain after the Flood. Herakles earned his place on Olympus by overcoming the worshippers of the God of Noah and his three sons, and instituting the serpent's system through the worship of Zeus and Athena. Unlike the Adam of Genesis, Herakles is not ashamed of his nakedness.

The Feasting Herakles

Scholars agree that Figure D's reclining position suggests a man enjoying a feast, and they usually restore a kantharos in one of his hands as a symbol of a pleasurable wine-drinking time. But as we have seen, the kantharos means much more. The word itself means "dung beetle" referring to the Egyptian scarab, signifying transformation and immortality. On this Attic red figure amphora (storage vase) from ca. 520 BC, Herakles feasts as Athena presents him with a rose. The reclining position represents the epitome of earthly enjoyment, and thus a similar pose on the Parthenon suggests the beginning of the endless pleasures of immortality.

The Apotheosis of Herakles

On this Attic red figure vase from ca. 410 BC, Athena, in her chariot, conducts the wreathed Herakles to Olympus. Herakles, naked except for the cloak draped over his left arm, holds his club in his left hand. Below is the flaming funeral pyre where his breast armor lies. Here and on the depiction on the following page, the ancient artists associate Herakles' nakedness with his immortality, perhaps in emulation of the sculptors of Figure D on the east pediment of the Parthenon.

The Marriage of Herakles and Hebe

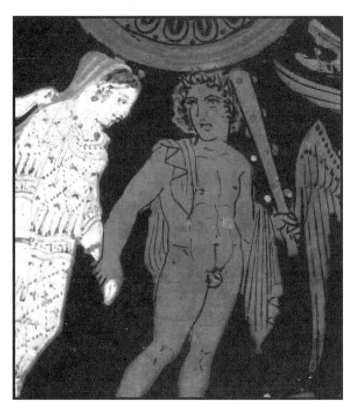

According to Pindar's *Nemean Ode*, Teiresias, the prophet of Zeus, predicted that Herakles would receive the goddess of youth as his bride after his death as a reward for his heroism in the battle of the gods against the Giants [see pages 120 to 123]. Herakles' heroics turned out to be crucial to the gods' victory over the Giants; thus, after Athena brought Herakles to Olympus in her chariot, he received Hebe in wedlock, becoming immortal in accord with the prophecy.

On this portion of the lid of a pyxis (cosmetics box) from ca. 350 BC depicting the marriage of Herakles and Hebe, we see Herakles naked but for a piece of draped cloth, carrying his club in his left hand. With his right hand, Herakles leads Hebe.

Herakles is Nimrod

Above left: royal Assyrian seal impression, ca. 840 BC, Assyrian king with a sword in single combat with a lion. Above right: clay tripod from Athens, ca. 740 BC, Herakles and the lion.

Herakles is Nimrod transplanted to Greek soil. Much of modern scholarship recognizes this fact. The labors of Herakles contain clear reminiscences of an earlier Mesopotamian tradition, and archaeological evidence from that region suggests that the figure of Herakles is found as early as the middle of the third millennium BC.

After the Flood, a rebellion believed to have been led by Cush, took place against the God of Noah in a city that came to be called Babel. Babel means confusion and drew its name from the fact that the God of Noah there "disintegrate[d] the lip of the entire earth" and "scatter[ed] them over the surface of the entire earth" (Genesis 11:9). Cush begot Nimrod whose name, in one interpretation, is a combination of *nin* or son, and *mrd*, meaning rebel. Nimrod was the son of the great rebel Cush, and an even more powerful rebel himself. He became a great hunter and benefactor of the men and women who were terrified by roaming wild animals after the Flood. Nimrod was the first to organize an army, build walled cities, and establish himself as king. But not con-

Attic black figure mastoid cup: Herakles attacking lion, ca. 520 - 500 BC.

tent with delivering men from the fear of wild beasts, he set to work also to emancipate them from the fear of Noah's God. As C. Uelinger has pointed out in *Dictionary of Deities and Demons in the Bible*, Jewish tradition has long considered Nimrod to be a paradigm of God-offending hubris.

The Book of Genesis says of Nimrod:

And Cush generates Nimrod. He starts to become a master in the earth. He becomes a master hunter before Yahweh Elohim. Therefore it is being said, "As Nimrod, the master hunter before Yahweh." And coming is the beginning of his kingdom to be Babel and Erech and Accad and Calneh, in the land of Shinar (Genesis 10:8-10).

As his first of twelve labors in the Greek tradition, Herakles kills the fierce lion of Nemea establishing himself as "a master hunter." In labors and battles subsequent to this, he is almost always depicted wearing the lion skin—a means of identifying him and reminding us of his great hunting prowess. Herakles' original name was Alcaeüs which means "mighty one."

The Meaning of the Sculpture over the East Entrance of the Temple of Zeus

On the temple of Zeus at Olympia, twelve 1.6 meter square metopes, six over the east entrance and six over the west, depicted the twelve labors of Herakles. The metopes shown on the opposite page are numbers three and four on the east side, making them the ones in the center just above the sacred entrance. Thus, they had a very special meaning to the ancient Greeks. The one to the left depicts Herakles killing the triple-bodied Geryon. The one to the right shows Atlas bringing the three golden apples from the tree in the Garden of the Hesperides to Herakles who, aided by Athena, upholds the heavens. Both metopes have to do with the question of spiritual authority in the Greek world.

There were no triple-bodied warriors in ancient days, any more than there are triple-bodied fighters today. And yet Herakles is here shown having killed two of Geryon's bodies, about to kill the third. What could a triple-bodied man signify? Noah had three sons: Shem, Ham, and Japheth. Nimrod's rebellion began during the time of their rule, after the death of Noah. By killing the triple-bodied Geryon, Herakles is figuratively overcoming the spiritual authority of Noah's three sons. After their deaths, Nimrod (Herakles) reigned supreme. But where did he get his authority? The adjacent metope answers that question—it shows us whose jurisdiction takes the place of that lost by the sons of Noah.

The metope with Athena, Herakles, and Atlas presents us with a picture of the serpent's Eve, the serpent's Adam, and Nimrod—the serpent's rebel after the Flood. Eve's part in pushing away God was very easy in the Garden. She simply believed the serpent. On the metope, there is neither tension in her arm nor strain on her face as Athena pushes away the God of the heavens. Likewise, with God pushed away,

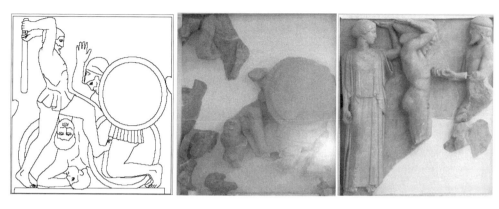

Above center: the fragmentary metope of Herakles killing the three-headed Geryon and to its left, a restored drawing of it. Above right: the well-preserved adjacent metope of Athena and Herakles uplifting the heavens as Atlas presents them with the golden apples of the Hesperides. These two metopes over the sacred east entrance to the temple of Zeus at Olympia commemorate Nimrod's rebellion, celebrate an end to the interference of Noah's oppressive God with Greek humanity, and acknowledge the authority of the ancient serpent as supreme.

it was no effort at all for Adam to take the fruit. On the metope, Atlas offers the apples to Herakles with ease and confidence.

Herakles' part in pushing away the God of Noah, on the other hand, took superhuman effort. He had to overcome the power of the sons of Noah. He had to fight, train other men as fighters, build walls, establish cities, and destroy wild animals. We see his strain on the metope. He needs a cushion on his shoulder to enable him to effectively put more of his weight into his effort. All this so that he could become the bearer of the golden apples from the serpent's tree, and the serpent's authority could replace that of the God of the three sons of Noah.

With the jurisdiction of Noah's three sons at an end thanks to Nimrod, and the God of Noah pushed away, humanity was again free to enjoy the golden apples from the serpent's tree. Those who felt restricted by the God of Noah could breathe freely and walk at liberty once again as they had done in the days of Cain and his line; and for this, such men

could not help but regard Herakles as a great benefactor. Remember that the Greek viewpoint was that the serpent enlightened Eve, and through her, all of humanity.

Thanks to Herakles (Nimrod), Zeus, the transfigured serpent, ruled the Greek world. That's why these metopes were directly over the sacred east entrance. As the Greeks looked up at these metopes over the doorway and walked under them, they surely understood what it was that enabled Zeus to take his place of rule over the Greek world, and be seated on the huge throne before them inside his temple.

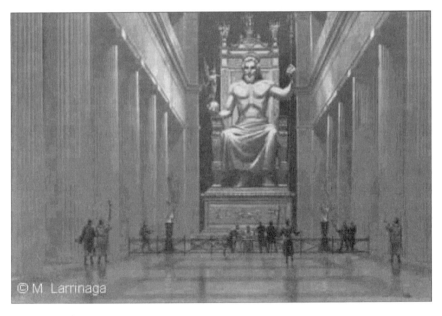

Painting of the idol-image of Zeus in his temple at Olympia. Phidias, the same artist who fashioned Athena's statue in the Parthenon, created this statue of her father as well. Both were chryselephantine, that is, a wooden core was overlaid with ivory for the skin and gold for the drapery. Zeus and Athena both displayed Nike in their right hands, and thus boasted of their joint victory—the victory of the serpent and Eve. The two metopes over the entrance to Zeus' temple affirmed Herakles' crucial role in reestablishing the serpent's and Eve's victory after the Flood.

The idol-image of Zeus in his temple at Olympia was one of the seven wonders of the ancient world.

According to Another Greek Tradition, Herakles (Nimrod) Had to Overpower Nereus (Noah) in His Quest for the Golden Apples of the Hesperides (the Fruit of the Tree of the Knowledge of Good and Evil)

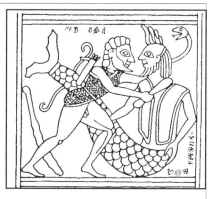

On this bronze relief shield band panel, ca. 550 BC, Herakles learns the location of the ancient garden from Nereus—the Old Man of the Sea. The inscription identifies the figures as Herakles and *Halios Geron* (The Salt Sea Old Man). This is Nereus whose name means "the wet one." The flame and the serpent erupting from his head indicate what Herakles is after— the enlightenment of the serpent. Herakles could only obtain this information from the great one from the pre-flood age—Noah. According to Genesis, Noah lived 600 years before the Flood and 350 years afterward.

On this Attic red figure hydria, from ca. 490 BC, Herakles, clad in lion's skin and short chiton and armed with sword, bow and quiver, pursues Nereus, the Old Man of the Sea, catching hold of his right wrist with his own right hand and reaching for his shoulder with his left. The Old Man of the Sea, identified by his flowing white hair, beard, and the fish he holds as an attribute in his left hand, walks to the right and turns around to face his pursuer as Herakles grasps his wrist. Nereus' bowed head and quiet resistance yield to the force of Herakles' youthful action. Nereus was the only one who knew the location of the tree of the knowledge of good and evil, and so Herakles had to go through him to get to the serpent's tree in the Garden of the Hesperides.

As the Greeks looked to Herakles on the East Pediment, They Understood the Connection Between His Immortality and His Role in the Defeat of the Giants Pictured on the Metopes Below

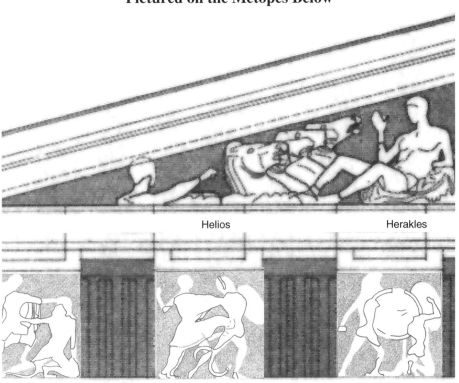

Helios Herakles

The fourteen metopes below the east pediment of the Parthenon depicted the gods defeating the Giants. They are in a sadly battered state, and identifying the figures in the individual metopes is highly speculative. We know from other sculptures, vase paintings, and literature that all the Olympian gods took part in the battle, with Zeus and Athena in the forefront, and the mortal hero Herakles playing the key, even indispensable role. As all the gods were victorious in concert, the defeat of the Giants represents the victory of the Greek religious system over an opposing religious system.

120

As we have seen, according to Pindar's *Nemean Ode*, Teiresias predicted that Herakles would receive Hebe (Youth) as his bride after his death as a reward for his heroism in the battle of the gods against the Giants—formidable foes of the gods who could not be defeated without Herakles' help. When that battle came about, the shining hair of many Giants was "stained with dirt beneath the rushing arrows of that hero." Thus after Athena brought Herakles to Olympus in her chariot, he married Hebe, becoming immortal in accord with the prophecy.

But what did this mean? What was its historical basis? We have to look to Genesis to find out. There, we discover that after the Flood, Nimrod became the first great hunter and king. And we have seen that Herakles is Nimrod transplanted to Greek soil.

After the Flood, faith in Yahweh was very strong, obviously. Within several generations and a couple of hundred years, that faith began to wane. This period is described thus in Acts 14:16: "God . . . in bygone generations, leaves all the nations to go their ways . . ." In the Greek story of the gods defeating the Giants, the Giants are the Yahweh-believing offspring of Noah, and the gods represent the Greek religious system. The fact that the gods could not win without the help of a man points directly to the historical figure, Nimrod, who began the organization of humanity into armies, cities, and nations, embracing the religious ideas of his father, Cush—the ring-leader at the Tower of Babel.

As the Greeks approached the east façade of the Parthenon in ancient days, they were undoubtedly able to make an instant connection between the fourteen metopes depicting the defeat of the Giants, and the immortal Herakles (Nimrod) above on the pediment. They knew that Herakles not only achieved endless life by fighting for the cause of the gods, but in effect, was the one who made possible the rebirth of the serpent's Eve sculpted in the center of the pediment.

"Cush was the father of Nimrod, who grew to be a mighty warrior on earth."

I Chronicles 1:10

Herakles' given name was Alcaeüs, meaning "mighty one."

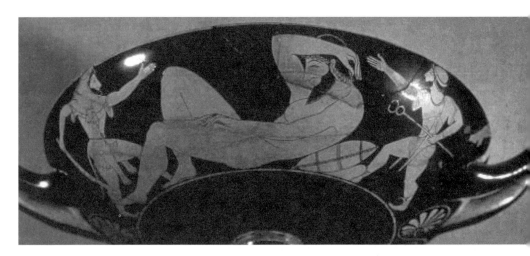

Attic red figure kylix (drinking cup): Herakles about to kill the sleeping Giant Alkyoneus, 525 BC. Hermes gestures to Herakles from the right. Cush (Hermes) and his son Nimrod (Herakles) overcame the sleeping Giants (the righteous sons of Noah), and put the serpent's system in place. The vase painter had a concise way of depicting the postdiluvian situation. The Yahweh-believing sons of Noah were indeed Giants; that is, larger than life, but they fell asleep; that is, they became vulnerable to the reestablishment of the serpent's system by Cush and his son Nimrod.

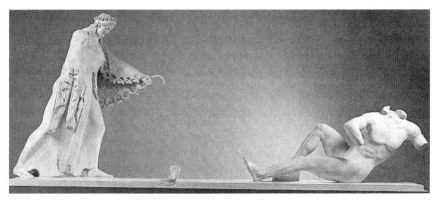

Part of the east pediment of the archaic temple of Athena on the Akropolis, ca. 520 BC. Athena, wearing her serpent crown and serpent-fringed aegis, kills a Giant.

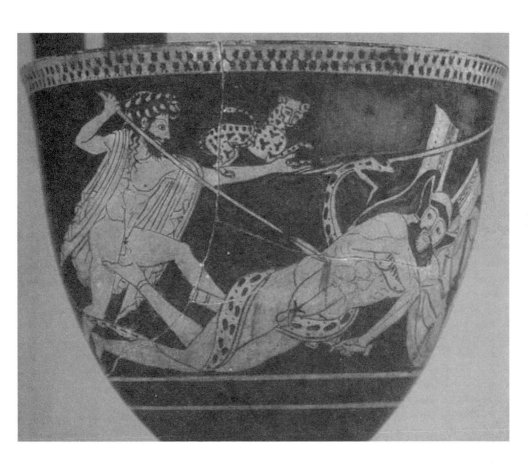

On this Attic red figure vase from ca. 510 BC, Dionysos kills a Giant. The tame leopard on the arm of Dionysos lets us know of Nimrod's (Herakles') crucial presence in the battle. *Nimr-rod* comes from *Nimr*, "a leopard," and *rada* or *rad*, "to subdue." The subduer of the leopard, Nimrod, brought back the religious system of the ancient serpent (shown here with a beard), and thus the Greek gods overcame the religion of the Giants—the Yahweh-believing sons of Noah.

Chapter 13

The Three Fates—Death Turned Back by the Immortal Athena

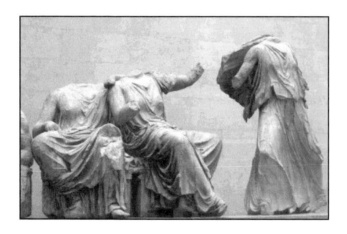

Figures E-F-G continue to puzzle scholars. The usual identification of E and F as Demeter, goddess of the earth's fertility, and her daughter Persephone doesn't work because their presence here does not relate to the birth of Athena. The identification of G as Hebe, goddess of youth, or Artemis, goddess of the hunt, runs into the same problem. Also, the standing Figure G, more than a head smaller than seated Figures E and

F, lacks the stature of a goddess. And why would Hebe or Artemis or whoever she is, turn away so abruptly from the central scene, while Demeter and Persephone, or whoever they are, exhibit such relaxed poses?

The answer is simple: these are the Three Fates, the *Moirae*. Their name means "parts" or allotted portions. Clotho spins the thread of life, Lachesis measures it, and Atropos cuts it. Figure E is Clotho, Figure F is Lachesis, and Figure G is Atropos. Why is Atropos so much smaller than her sisters? The answer is that Hesiod, in his *The Shield of Herakles*, says she is. He describes a scene on Herakles' shield whereon "the dusky Fates, gnashing their white fangs," hover over a bloody battle. "Clotho and Lachesis were over [the wounded]," he writes, "and Atropos less tall than they, a goddess of no great frame, yet superior to the others and the eldest of them." And so the puzzle of Figure G's lesser stature is solved.

Atropos (α-τροπος) means unturnable. The idea is that she cannot be stopped from cutting the thread of life when the time has come. But here, on the east pediment of the Parthenon, Atropos is in the very process of turning. Why? How can that be? Remember what Pausanias wrote—"All the figures . . . relate to the birth of Athena." Athena's birth as the transfigured serpent's immortal Eve has the power to turn back fate. A-tropos, the one who cannot be turned back, must now yield to A-thanatos, the one who cannot die. Clotho and Lachesis, their work done, react in joint amazement at Athena's birth. But Atropos, confronting the birth of the immortal Athena, unable to complete the work of her sisters, turns back abruptly. And so the puzzle of Figure G's turning anxiously back toward the relaxed E and F is solved.

The evidence also shows that the pose of Figure F connects Athena's immortality with that of Herakles. As Kristian Jeppesen has pointed out, indications preserved at the neck of Figure F show that her head was tilted and turned rather sharply to her right. Since she is leaning eagerly forward and seems not to pay any attention to her companion Figure E, she must be looking to Herakles. Figure F is Lachesis. She is

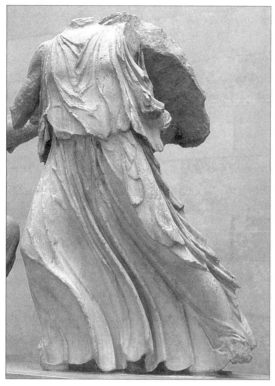

Atropos' dress reacts naturally to her abrupt turning back, masterfully depicting the desired motion in a marble figure. Atropos was the Fate who could not be turned—except by Athana(tos), the deathless one, to whose birth Atropos reacts.

the one who measures the thread of life. What an honor to measure the thread of Athena's powerful and endless life! Thus the arms of Lachesis reach toward Athena in an all-embracing gesture, and she looks over her shoulder to Herakles, who in turn was rewarded with immortality for his faithful service to Athena and Zeus. Her open arms welcome her sister Atropos also, for the turning back of Atropos relates directly to the birth of the immortal Athena.

And again the goddess murky Night [Nyx], though she lay with none, bare Blame and painful Woe, and the Hesperides who guard the rich, golden apples and the trees bearing fruit beyond glorious Ocean. Also [Nyx] bore the Destinies and ruthless avenging Fates, Clotho and Lachesis and Atropos, who give men at their birth both evil and good to have . . .

Hesiod, *Theogony*

Helios · Herakles · The Three Fates

The rising of Helios shines upon the birth of Athena heralding a new day and a new age. Herakles, who helped bring the new day into being enjoys his reward of immortality. The first two Fates, Clotho and Lachesis, welcome Athena's birth, as the third, Atropos, turns back acknowledging her inability to cut the thread of life belonging to the immortal goddess. The Fates here on the left side of the pediment and the Hesperides on the right, balance each other as children of Nyx, or Night.

Chapter 14

Nike Amplifies the Victory of Zeus and Athena

Nike is not the deification of a dead person, but rather the representation of an abstraction. She is Victory. Specifically, she is the Victory of Zeus and Athena. Zeus holds her in his right hand in his temple at Olympia; Athena holds her in her right hand in the Parthenon. Nike is an attribute of Zeus and Athena which means that Victory belongs to Zeus and Athena. Nike is an attribute of no other god.

Nike symbolizes the Victory of the serpent in the Garden. Zeus represents two beings: the transfigured serpent and Adam, and Athena represents Eve. So in a deeper sense, the Nike of Zeus and Athena is the Victory of Adam, Eve and the serpent over the God Who created the Garden of Eden.

On the next page, we see part of a vase painting with Nike driving the chariot of Zeus who holds his lightning bolt, a symbol of the moment of lighting up—the dawn of human self-consciousness in Eden. Forgive the pun, but it is very revealing that Zeus is naked. The Judeo-Christian viewpoint has Adam ashamed of himself after eating of the tree. But on this vase we have a picture of an unashamed Adam who has eaten of the fruit. From the viewpoint of Greek religion, taking the fruit from the tree of the knowledge of good and evil did not bring shame, but Victory. A naked Zeus boasts of the great Victory that is his at the moment of lighting up. No foe can challenge his Nike.

NIKE AMPLIFIES THE VICTORY OF ZEUS . . .

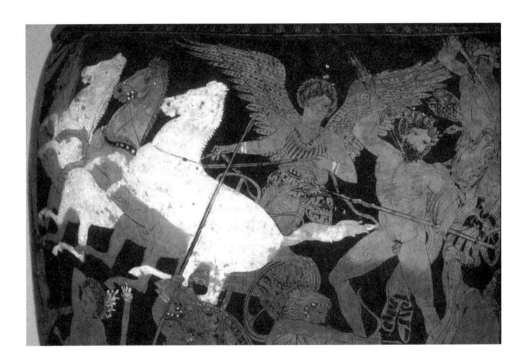

Zeus attains victory over the Giants, detail of Attic red figure amphora, ca. 400 BC. Zeus aims his lightning bolt at his enemies. Next to Zeus, Nike with wings outspread, drives his quadriga—a chariot drawn by four horses abreast. Her presence symbolizes the victory of Zeus over all his enemies, and his rule over all earthly kingdoms.

. . . NIKE AMPLIFIES THE VICTORY OF ATHENA

On this Attic red figure vase from ca. 435 BC, we see Athena, dressed as Athena Parthenos, holding a spear in her left hand and Nike in her right. Nike, or Victory, belonged jointly to Zeus and Athena.

Athena's Nike Turns Back
Atropos and Extols the Virtues of Herakles

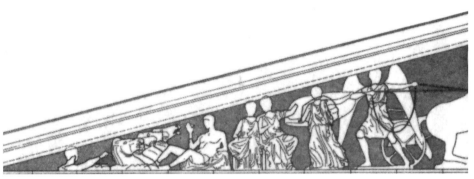

Helios Herakles The Three Fates Nike

The birth of Athena from the head of Zeus is all about mankind's Nike, or Victory, so we know beyond a doubt she had a prominent place on the east pediment. Fragments exist which show that there were horses near the center of the pediment. The sculptors most likely depicted Nike as a charioteer because of the chariot's association with power. Logically, she belongs between Athena and the Three Fates. If we place Nike as above, the message of the Fates is even clearer. We see that Atropos is not simply turning back from the immortal Athena, but from the immortal Athena's Victory. Nike relates to Herakles as well, for he has attained Victory over death through his obedience to, and worship of Athena and Zeus. This is a very important idea for the Greeks. Herakles at one point in his career had murdered his children, one of the most heinous of crimes. If he, through good works and obedience to the gods, could obtain immortality, the average Greek could do so as well. This part of the pediment probably meant more to them than any other part. Herakles was the hope of the Greeks.

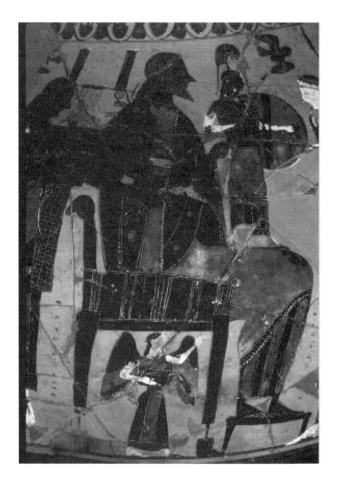

This scene from an Attic black figure amphora ca. 550 BC depicts the birth of Athena. Not yet full size, she stands on Zeus' lap while other deities gather around. Zeus, seated on a throne in the center of the scene, reaches toward Athena with one hand while holding a stylized lightning bolt in his other hand. He wears a headband over his long hair. The throne has a ram's head on the visible end of the backrest. Athena is standing on Zeus's lap facing right. Although small in stature, she is fully dressed and is armed with helmet, shield and spear. A small, winged Nike stands beneath the throne, raising the palm of her left arm upward. Her presence tells us that the seat of Zeus at the moment of lighting up has become the throne of Victory for humanity.

The Winged Victory of Samothrace

The famous Nike from the Aegean island of Samothrace in the Louvre Museum in Paris. This eight-feet-high marble figure, created by a Rhodian sculptor between 220 and 190 BC, portrays the goddess of victory alighting on a ship's prow, with her wings spread and her clinging garments rippling in the wind. This Nike's form may have been inspired by the Nike on the east pediment of the Parthenon.

Chapter 15

Summary of the East Pediment Sculptures

The ancient travel writer, Pausanias, has told us that "All the figures in the gable over the entrance to the temple called the Parthenon relate to the birth of Athena." And we have read Pindar's account, among others, of that most unique birth: "By the skills of Hephaistos with the bronze-forged hatchet, Athena leapt from the top of her father's head and cried aloud with a mighty shout. The Sky and mother Earth shuddered before her." Based on this information, other ancient sources, and the physical evidence, we have been able to reassemble the pieces of the puzzle.

The sculptures of the east pediment of the Parthenon are narrative art. The idea that the Greeks believed that their god of the forge literally

Left: head of Zeus from the Roman period, after 130 AD, most likely in imitation of Parthenon Zeus. Right: head of Hera from a cult image at Olympia, ca. 600 BC.

cracked open the head of Zeus and out popped Athena ready for battle is truly absurd. Such a view implicitly makes fools out of those who established the living basis of our culture. Two of the most important qualities of classical art are rationalism and realism, and what the east pediment depicts is both rational (it makes sense) and real (it is history).

The scene, *in toto*, presents us with a story—what the Greeks believed to be a true story. The sculptural presentation straightforwardly explains how the Greeks accounted for their existence, answering all the important questions: who, what, when, where, why, and how. The east pediment scene speaks for the Greeks. I can imagine the chief sculptor, Phidias, saying to us over the span of centuries, "Welcome to our world. Welcome to what we have painstakingly carved into marble so that you might know what we believe about ourselves."

We have learned that the four figures in the middle of the pediment are Zeus, Hera, Athena, and Hephaistos. These gods present us with the central truth of Greek religion. We will begin our review with the father of gods and men.

Zeus

Zeus is the true focal point on the east pediment. The scene at the center is almost always referred to as "the birth of Athena," but it is more accurately described as "Zeus birthing Athena." Zeus is the one who brings Athena into being, and he is the one who ordains that all of what we see on the pediment might be so.

Zeus, the serpent transfigured into an image of Adam as the "father of gods and men," is the chief actor in the unfolding drama. His lightning bolt in his right hand, barely visible in the drawing on page 141, suggests his power, but more obviously, the moment of lighting up, that instant, that flash of time when Eve received the knowledge of good and evil, and human history as we know it began. The name Zeus in Greek, *Dios*, means at its deepest level "the moment of lighting up."

Zeus and his wife, Hera, have controlled human destiny up to the point of Athena's birth. But this is a new age, the Greek age, a new beginning for mankind after the Flood. The central figures represent the rebirth of the serpent's system after the Flood, and the central event is the rebirth of the serpent's Eve, the essence of Zeus-religion. And Zeus will control human destiny through Athena in the Greek age.

Hera

The Greeks knew Hera as the wife of Zeus, and as the goddess of childbirth and marriage. As such she is a picture of the first woman, the first woman to give birth, and the first woman to marry. She is a picture of the primal Eve. She remains the great queen of heaven but it is after the Flood now and Herakles has completed his labors unifying Greek humanity in the service of his father, Zeus. And from the serpent-entwined tree in the paradise of the Hesperides, Herakles has taken the sacred golden apples which once belonged to Hera and given them to his patroness, Athena. In the central scene, Hera is not armed for it is Athena, as goddess of war and wisdom, who will now do battle for her father Zeus.

Athena

Athena's coming into being out of Zeus is a marvelously concise picture of the key event—the world-shaking event—in Eden. Zeus is a picture of Adam as "the father of gods and men." Eve came out of Adam. Athena, the Greek Eve, came out of Zeus, a deified picture of Adam. Athena's coming into being out of the head of Zeus also signifies that she is the brain-child of the transfigured serpent. The age in which we live, the age initiated by the Greeks, is a new postdiluvian age, a new beginning, a new system which exalts Eve's wisdom in eating the fruit of the tree in the Garden, a wisdom with the power to establish the foundation of a human culture lasting thousands of years. Athena, the new Eve, is fully-armed to fight for the Greek religious system, and for the city that bears her name.

Head of Athena from the west pediment of the temple of Aphaia on the island of Aegina ca. 500 BC.

Eve's seed, Genesis said, would bruise the head of the serpent. Noah, a righteous seed of Eve, figuratively did just that by surviving the Deluge which destroyed the entire line of Cain. After the Flood, with the line of Cain reestablished, Athena, the serpent's Eve, made certain the curse of Genesis could not operate in the Greek age, for she would remain Athena Parthenos, Athena the maiden, Athena the virgin without offspring. There is no seed of this woman to crush the serpent's head in the Greek age. Yahweh's curse is thus broken, and the serpent's promise to Eve—"Ye shall not surely die"—is made manifest, for Athena is A-thana(tos), the deathless one.

Hephaistos

In the Book of Genesis, Eve and Adam both eat the forbidden fruit, but then they become sorry that they believed the serpent and repent. Their eldest son Cain, however, chooses the serpent's wisdom and re-

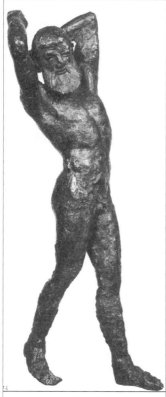

Hephaistos in bronze from ca. 450 BC. The position of his arms indicates he once held a blacksmith's hammer.

sents his brother Abel's worship of Yahweh. Cain kills Abel. He is not sorry and so does not repent. Through Cain, the serpent's wisdom finds a line of development. Cain doesn't see the serpent as an adversary but as a friend, an illuminator, and a god.

Hephaistos, the eldest son of Zeus and Hera, is a deification of Cain, the eldest son of Adam and Eve. His unbelief in the ways of Yahweh releases the serpent's religious system into his mind and heart, and subsequently into the minds and hearts of his offspring. That is why he is the one who is pictured cracking open the head of Zeus to release the serpent's Eve. He is a hero to all who welcome the serpent's enlightenment. Cain's violent act reopens the door to all the serpent had promised.

It is noteworthy that in Greek myth, Zeus never complains of what should have been a gapping and bloody hole in his head after the blow of Hephaistos' axe. An axe-blow to the head causes problems for the smitten one, and yet on none of the many extant vase depictions of Athena's birth do we note any damage at all to Zeus. Furthermore, Hephaistos is never depicted in the act of delivering his axe-blow, but always afterwards. The myth of Athena's birth is not telling us that

Zeus was severely wounded by a blow to the head from Hephaistos, but rather that a vicious and violent act set free the worship of the serpent's Eve and, of course, the worship of the transfigured serpent. At its deepest level, Hephaistos' assistance at the birth of Athena is simply read this way: in the beginning of humanity's days, a violent act initiated by a man enabled mankind to receive the serpent's enlightenment and to worship the serpent's Eve. The violent act is the murder of Abel, and the man who initiated it, Cain.

This setting free of the serpent's wisdom after the Flood through the power of Hephaistos' axe is crucial to the development of the Greek religious system. Everything else depends on it. Now let's summarize the meaning of this central scene.

Summary of the Central Scene

Zeus' birthing (bringing into being) of Athena as goddess of the new Greek age after the Flood is the central event on the pediment to which all the other sculptures relate. Zeus, the transfigured serpent, stands at the apex of the triangle. This is his system and his religion. He takes the form of Adam whom Scripture identifies as the father of all mankind. Greek myth makes him the father of gods (deified mortals) and men. To Zeus' proper left stands Hera, a picture of the primal Eve. Eve is the mother of all living, and sister and wife of Adam. So Hera, in Greek myth, is the goddess of childbirth, sister and wife of Zeus, and goddess of marriage.

To the proper left of Zeus and Hera stands their eldest son, Hephaistos. This is the deified Cain, the corresponding eldest son of Adam and Eve, standing next to the deifications of his parents. He carries his axe as evidence that he has just committed a violent act. While Cain's murder of Abel is only alluded to here, in the next book of the series we will find it depicted in some detail on what scholars refer to as "the mysterious south central metopes" of the Parthenon. Now, as a result of Cain's violent act, Athena is able to emerge from the head (the mind) of Zeus the transfigured serpent, and stand before him to his proper right.

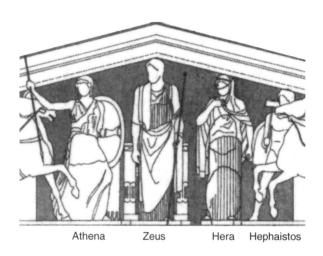

Athena Zeus Hera Hephaistos

The knowledge of good and evil and the serpent's promise of immortality are hers. She passes on the knowledge of good and evil, and the promise of the afterlife to Greek humanity.

Now that we understand who the central figures are and how Athena's birth relates to Eden, we can easily discern the meaning of the surrounding sculptures which provide the background for, and significance of, the pivotal scene.

The Background of Athena's Birth
The Right Side of the Pediment

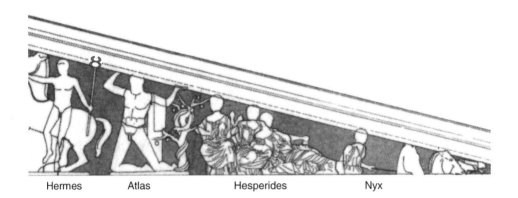

| Hermes | Atlas | Hesperides | Nyx |

Nyx

The surrounding sculptures should tell us when and where the central scene takes place, and they do. Nyx, representing Night or Darkness, leaves the scene in her chariot to our far right. She gives us the time frame we need. Hesiod tells us that Nyx came out of Chaos. Chaos is as far back as Hesiod is able to trace the origins of the cosmos, and Nyx is the first concept he can truly understand. We see Nyx in the right corner of the pediment but Chaos has disappeared completely, as the Greeks, in this panorama, begin to bring order out of Chaos; that is, they begin to make sense of their place in the universe. Hesiod also tells us that out of Nyx came the Hesperides and the Three Fates, both of whom are depicted on the pediment on opposite sides in corresponding positions. Nyx departs, so our scene is set after her departure, at the time the Hesperides existed, and more specifically, at the time the Three Fates, representing death, came into being.

142

The Hesperides

The depiction of the Hesperides next to Nyx helps us understand when the central event—the birth of Athena—took place, but most importantly, it tells us *where* it took place. The Hesperides are a collective iconograph representing paradise. On the extant vase paintings, the Hesperides are always pictured with a serpent-entwined tree. A paradise, a tree, and a serpent: in terms of Genesis, this is Eden. This is where, Phidias is telling us, the original and central event took place.

Atlas

The presence of Atlas next to the Hesperides explains how Eve's choice became possible. The oppressive God Who had temptingly placed the tree of the knowledge of good and evil in the midst of the Garden and yet forbade that its fruit be eaten had to be pushed away from the scene before humanity could make any progress. This idea, Atlas pictures perfectly. He pushes away the heavens and with them, the God of the heavens. The raking cornice represents the lower limit of the heavens. As Atlas pushes upward, he enables the transfigured serpent to stand triumphant at the apex of the triangle.

Hermes

Like Nike on the opposite side, Hermes has a transitional function in our panorama. As the deified Cush, the high priest of rebellion in Babylon, he links what happened in the Garden (Atlas and the Hesperides) to the central scene. For the birth of Athena is in reality the *rebirth* of the serpent's Eve after the Flood, and Hermes is instrumental in bringing about that rebirth. Kekrops, depicted as a half-man and half-serpent, was the king who established Zeus-religion in Athens. The Greeks taught that Kekrops sacrificed to Hermes, meaning that he looked to Hermes, the deified Cush, as his religious mentor. Hermes was the original and chief herald of Zeus-religion (the serpent's system) in the ancient Greek world.

The Power and Promise of Athena's Birth
The Left Side of the Pediment

Nike

Nike, to Athena's proper right, amplifies the great victory of Zeus and Athena. Athena's victory forces Atropos, the Fate who cuts the thread of life, the unturnable one, to turn back toward her two sisters. A-tropos, must yield to A-thana(tos), the deathless one. The Greeks believed that the serpent's promise was true; and so to them Eve did not die, but became as the gods, knowing good and evil.

The Three Fates

The presence of the Three Fates on the this side of the pediment pinpoints the time of the birth of Athena in the garden of the Hesperides. Clotho spins the thread of life, Lachesis measures it, and Atropos cuts it, and thus the Three Fates signify death. Death became part of the human condition when Eve picked the fruit in the Garden. That is the very moment when Zeus, the transfigured serpent, birthed Athena from his head, the moment Eve became convinced that heeding the serpent was the path to victory, the moment of lighting up, the instant Eve obtained the knowledge of good and evil.

Herakles

On the other side of the Fates, Herakles, the man-become-god, revels in the victory of Zeus and Athena for it is the basis of his Olympian life. The common people looked to him as a helper and giver of strength in their day-to-day difficulties. For them, Herakles bridged the gulf between mortality and immortality. The Greeks understood what it was that gained Herakles a happy, endless life: his unswerving devotion to Athena, and his exemplary obedience to the will of Zeus. Herakles' presence on the east pediment was an example and a lesson for them. Herakles gave them hope.

144

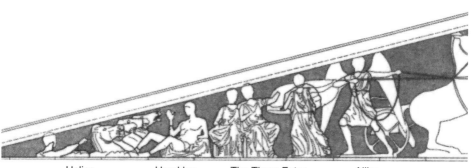

| Helios | Herakles | The Three Fates | Nike |

Herakles is the Greek version of Nimrod from Genesis, the great benefactor of humanity who reestablished and enforced the way of Cain after the Flood. From the gods' point of view, Herakles earned his place on Olympus by overcoming the worshippers of the God of Noah, and instituting by his strength and conquests Zeus-religion (the serpent's system) in the postdiluvian world.

Helios

In the left corner, Helios, the sun, rises to herald the dawn of the great Greek age. His light illuminates the birth of Athena, the victory (Nike) of Zeus and Athena, and the well-deserved immortality of Herakles. Figuratively, the light from Helios is the serpent's enlightenment in which Zeus-religion glories.

I encourage you to ponder the brilliance of the Greeks in their east pediment depiction of the most momentous events in the history of humanity. This is the story of Eden and the reestablishment of the serpent's system after the Flood. Phidias, the chief sculptor, compressed time and space to relate all the elements of the story at once. I cannot conceive of a way in which those events could have been encapsulated any better, in any medium. We will look into why these truths and others have remained hidden for so long in subsequent books in the series.

Epilogue

[Myth] is a scrupulously chosen pictorial device designed to evoke an idea or concept in its entirety. It is a means of bypassing the intellect and talking straight to the intelligence of the heart, the understanding.

John Anthony West in *Serpent in the Sky: The High Wisdom of Ancient Egypt*

Greek myth is history. Essentially, it tells us the same story as the Book of Genesis, but from the standpoint that the serpent is the enlightener of mankind rather than its deceiver. More to the point of this book: it is not possible to comprehend the meaning of the east façade of the Parthenon—a sculpted expression of the very heart of Greek religion itself—unless one sees the direct connection between Athena and Eden.

Many more profound messages await us in the other sculpted scenes on the Parthenon, messages that have eluded academia since the early 1800's when their efforts to decipher them began in earnest. Nigel Spivey, in his *Understanding Greek Sculpture*, greatly understates the situation in academia today when he writes of the "limited success of scholars in clarifying the iconographic components of the [Parthenon's] pedimental ensembles." Outside the context of the Book of Genesis, the "iconographic components" have no real meaning at all. Only when one sees that Athena is Eve, do the sculptures and the myths come alive and make sense to us, as they made sense to our cultured, literate, and thoughtful ancestors, the ancient Greeks.

It is a sad fact that, with rare exception, the mythologists and Classical scholars of today do not take the Book of Genesis seriously. One of the most widely-read (and mistaken) mythologists, the late Joseph

Campbell, stated categorically that there was no Eden. He further deni-grated Genesis and those who do take it seriously by writing, "No one of adult mind today would turn to the Book of Genesis to learn of the origins of the earth, the plants, the beasts, and man." How could Mr. Campbell look at a vase depiction of the Hesperides with the fruit tree and serpent without thinking of Eden? How could any scholar examine a vase picturing Athena coming out of Zeus full-grown without think-ing of the way Eve came out of Adam? Or look at a marble sculpture showing a giant bearded snake being worshipped as Zeus without think-ing of the ancient serpent? Or view a metope of Herakles presenting the sacred apples to Athena without thinking of the tree of the knowledge of good and evil? Or see a vase picture of the half-man, half-serpent Kekrops without thinking: "The serpent's man!"?

There is a more basic question. Meeting the ancient Greeks at eye level as they entered the Parthenon was the statue base of the great idol-image of Athena. In the center of it, surrounded by the gods giving her gifts, stood a sculpted Pandora—the woman who according to Greek myth was responsible for letting evil out into the world. Could not a schoolchild grasp that Athena's gold and ivory grandeur above Pandora was literally *based* on this obvious picture of Eve?

A huge amount of evidence from Greek myth, in both art and litera-ture, points to an Eden, and yet the scholars have been unable to make the connection. Even as they meticulously assemble fact after valuable fact, they continue to shun the only context into which these facts fit.

If they wish to move on from knowledge to understanding, if they wish to pass on wisdom to their students, that has to change. Wisdom is that faculty which makes the highest and best application of knowledge. Demeaning or ignoring the Book of Genesis is not wisdom. Genesis, in the original Hebrew (and translated concordantly), is a valid historical document. The stone sculptures of the Parthenon cry out that this is so.

ART AND IMAGE CREDITS (Page Numbers in Bold Type)

Introduction

11. Cutaway drawing (after g. Niemann) of Parthenon's east façade scanned from page 16 of Cook's *The Elgin Marbles*.

Chapter One: The Pieces of the Puzzle

13. Parthenon Photograph, east façade from the East, courtesy of the Department of Archaeology, Boston University, Saul S. Weinberg Collection. (Perseus Library).

16, 18. Drawings of Jaques Carrey scanned from page 59 of B. F. Cook's *The Elgin Marbles*, and courtesy of the Bibliothèque Nationale, Paris.

16, 17, 18. Sculpture photos courtesy of the British Museum, London.

19. Hera fragment in the Akropolis Museum, Athens, is scanned from page 251 in the chapter by Evelyn B. Harrison ("The Sculptures of the Parthenon") in *The Parthenon* edited by Vincent J. Bruno.

19. Figure H (Atlas) is scanned from *The Parthenon Kongress*, 1982.

19. Figure N (Nyx) is a scan of figure 80.4 in John Boardman's *Greek Sculpture: The Classical Period*.

Chapter Two: The Central Figures—Zeus, Hera, Athena, and Hephaistos

22. Birth of Athena, black figure vase depiction, Boston 00.330, courtesy Museum of Fine Arts, Boston. H. L. Pierce Fund (Perseus Library).

22. Hephaistos image from Parthenon.org Web site.

23. Zeus, Athena, Hephaistos black figure: London B 424. Photograph courtesy of the Trustees of the British Museum, London (Perseus Library).

24. Birth of Athena, red figure hydria: Paris, Cabinet des Medailles, 444. Copyright © Beazley Archive 1997-2001.

25. Birth of Athena, Archaic Attic black figure, Sotheby's Market, London. Copyright © Beazley Archive 1997-2001.

26. Drawing of Athena, Zeus, and Hera by K. Iliakis from Parthenon Kongress, 1982.

26. Head of Hera from the Akropolis Museum, Athens, is scanned from page 254 of the chapter by Evelyn B. Harrison ("The Sculptures of the Parthenon") in *The Parthenon* edited by Vincent J. Bruno.

28. Olympia East Pediment, Fig. H (Zeus), Olympia Archaeological Museum. Photograph by Maria Daniels, courtesy of the Greek Ministry of Culture (Perseus Library).

Chapter Three: Athena—The Deified Eve

31. Painting scanned from page 57 of *The Ancient City: Life in Classical Athens and Rome* by Peter Connolly and Hazel Dodge.

33. Reconstruction of the Athena Parthenos in the Royal Ontario Museum, photograph courtesy of the Royal Ontario Museum, Toronto, Canada (Perseus Library).

34. Athena Parthenos, statuette of Roman date. Copy from Phidias' work 438 BC. Antikmuseet, Lund. Athena Parthenos, 2514 Photo © Maicar Förlag – GML (Perseus Library).

35. *Eve* by Albrecht Dürer, oil on panel, 1507, Museo del Prado, Madrid.

35. *Athena Parthenos*, full-size reproduction in the Nashville Parthenon by Alan LeQuire (Parthenon.org).

36. Perseus, Attic black figure, London B 471, photograph courtesy of the Trustees of the British Museum, London (Perseus Library).

36. Athena with Gorgon on aegis, Attic red figure, Berlin F 2159, photograph by Maria Daniels, courtesy of the Staatliche Museen zu Berlin, Preußischer Kulturbesitz: Antikensammlung (Perseus Library).

37. Athena with serpent crown is scanned from page 218 of John Boardman's *The Parthenon and Its Sculptures*.

37. Athena and serpent killing the Giant Enkelados from *Ancient Art and Architecture* www.geocities.com/Athens/Crete/9169/greek.html.

38. Athena's shield, on Attic black figure neck amphora ca. 525 BC, Boston 01.8026. Photograph courtesy of the Museum of Fine Arts, Boston (Perseus Library).

38. Athena and Erichthonios on Attic red figure pelike ca. 435 BC, London E 372. Photograph courtesy of the Trustees of the British Museum, London (Perseus Library).

Chapter Four: Zeus—The Transfigured Serpent

40. Serpent relief scanned from page 18 of Jane Ellen Harrison's *Prolegomena to the Study of Greek Religion*.

41. Serpent relief scanned from page 19 of Harrison's *Prolegomena*, above.

43. Serpent drawing scanned from page 20 of Harrison's *Prolegomena*, above.

45. Altar of Zeus from *Ancient Greek Art and Architecture*, www.geocities.com/Athens/Crete/9169/greek.html.

45. Serpent head scanned from illus. 16, east frieze section, in *The Great Altar at Pergamon* by Evamaria Schmidt.

46. Hermes, Zeus, and Iris, Attic red figure vase. Photograph by Maria Daniels, courtesy of the Musée du Louvre, G 192 (Perseus Library).

47. Hermes, Attic black figure hydria Toledo 1956.70. Photograph by Maria Daniels, courtesy of the Toledo Museum of Art (Perseus Library).

47. Hermes, Attic red figure vase, collection of the J. Paul Getty Museum, Malibu, California, Malibu 83.AE.10 (Perseus Library).

48. Kekrops, Attic red figure, Berlin F 2537 Photograph by Maria Daniels, courtesy of the Staatliche Museen zu Berlin, Preußischer Kulturbesitz: Antikensammlung (Perseus Library).

48. Kekrops and Nike scanned from page 45 of Ellen D. Reeder's *Pandora*, credited to London, British Museum, inv. no. E 788.

49. Athena/Poseidon hydria scanned from page 454 of John Boardman's (et. al.) *The Art and Architecture of Ancient Greece*.

49. Olympia East Pediment, Fig. H (Zeus). Olympia Archaeological Museum. Photograph by Maria Daniels, courtesy of the Greek Ministry of Culture (Perseus Library).

52. Massacio's fresco *Expulsion from the Garden of Eden* in the Brancacci Chapel, Florence, Italy. Image © Web Gallery of Art, created by Emil Kren and Daniel Marx.

52. Rudolph Tegner's *Zeus Giving Birth to Athena* in Rudolph Tegner's Museum, Denmark, image from Carlos Parada's Greek Mythology Link (Web site). Photo © Maicar Förlag –GML.

Chapter Five: Hera—The Primal Eve

54. Temple of Dione. Photograph by Beth McIntosh and Sebastian Heath (Perseus Library).

55. Albrecht Dürer etching, *Adam and Eve* from Olga's Gallery (Web site).

56. Hera and Zeus from the east frieze of the Parthenon courtesy of the British Museum, London.

57. Enthroned Hera, RISD 25.078. Photograph by Maria Daniels, courtesy of the Museum of Art, Rhode Island School of Design, Providence, RI (Perseus Library).

58. Wooden Zeus and Hera scanned from illus. 57, page 70 of *Greek Art* by John Boardman, fourth edition.

59, 60, 61, 62. Herakles entering Olympus, Attic red figure, Villa Giulia 2382. Rome, Museo Nazionale di Villa Giulia. Photograph by Maria Daniels, from Furtwängler & Reichhold, pl. 20 (Perseus Library).

64. Herakles strangling snakes, Attic red figure, Louvre G 192. Photograph by Maria Daniels, courtesy of the Musée du Louvre (Perseus Library).

65. Nike and Hera, Attic red figure, RISD 35.707. Photograph by Maria Daniels, courtesy of the Museum of Art, RISD, Providence, RI (Perseus Library).

66. Temple of Hephaistos photograph courtesy of the Department of Archaeology, Boston University, Saul S. Weinberg Collection (Perseus Library).

66. Drawing of Hephaistion metope scanned from page 151 of John Boardman's *Greek Sculpture: The Classical Period*.

67. Sphinx, Photo Maria Daniels, courtesy of the Greek Ministry of Culture and Delphi Museum (Perseus Library).

67. Athena Parthenos: Roman copy of Phidias' work 438 BC, from Carlos Parada's Greek Mythology Link (Web site). Photo © Maicar Förlag –GML.

Chapter Six: Hephaistos—The Deified Cain

70. Foundry scene, London B 507. Photograph courtesy of the Trustees of the British Museum, London (Perseus Library).

70. Hephaistos, Attic red figure. Photograph by Maria Daniels, courtesy of Harvard University Art Museums (Perseus Library).

72. Bronze relief scanned from illustration 98 in T. H. Carpenter's *Art and Myth in Ancient Greece*.

72. The Temple of Hephaistos across from the Agora, Athens. Photograph courtesy of the Department of Archaeology, Boston University, Saul S. Weinberg Collection (Perseus Library).

73, 74, 75. Return of Hephaistos, Attic red figure, Toledo 1982.88. Photograph by Maria Daniels, courtesy of the Toledo Museum of Art (Perseus Library).

Chapter Seven: Nyx—The Darkness out of Which Arose Paradise

78. Figure N (Nyx) is a scan of figure 80.4 in John Boardman's *Greek Sculpture: The Classical Period*; Akropolis Museum, Athens.

78. Photo of Figure O, horse of Nyx, courtesy of the British Museum, London (Perseus Library).

Chapter Eight: The Hesperides—A Picture of Paradise

85. Figures K-L-M. Photograph courtesy of the British Museum, London.

86. Painting of figures K-L-M scanned from page 71 of Peter Connolly's *The Ancient City*.

87. Hesperides, Attic red figure hydria, London E224. Photograph courtesy of the Trustees of the British Museum, London (Perseus Library).

89. Bearded serpent hydria, Champaign 70.8.4, Krannert Art Museum, University of Illinois. Photograph courtesy of the Krannert Art Museum, University of Illinois (Perseus Library).

89. Hesperides at fountain, Attic red figure pyxis, London E 772, British Museum, London. Photograph by Maria Daniels, from Furtwängler & Reichhold, pl. 57, 2 (Perseus Library).

90, 91. Apples of Hesperides metope and detail scanned from illustrations 186 and 188 in *Olympia: The Sculptures of the Temple of Zeus* by Bernard Ashmole and Nicholas Yaloris.

Chapter Nine: Atlas Pushes Away the Heavens, and with Them, the God of the Heavens

94. Atlas torso in the Akropolis Museum, Athens, scanned from *Parthenon Kongress*.

95. Model pose and drawing scanned from *Parthenon Kongress*.

97. Herakles in the Garden of the Hesperides, Attic red figure krater, Malibu 77.AE.11. J. Paul Getty Museum, Malibu, California (Perseus Library).

Chapter Ten: Hermes, the Deified Cush, Connects Eden with the Rebirth of the Serpent's Eve

101. Herm scanned from page 29 of Peter Connolly's *The Ancient City*.

102. Youth adoring a herm, Attic red figure kylix, Philadelphia MS2440. Photograph by Maria Daniels, courtesy of The University Museum, Philadelphia (Perseus Library).

103. Hermes runs from Chiron, Attic black figure amphora, Munich 1615A. Photograph copyright Staatl. Antikensammlungen und Glyptothek, München (Perseus Library).

104. Drawing of lion metope: Copyright C. H. Smith 1990 (Perseus Library).

Chapter Eleven: Helios—The Rising Sun Heralds the Birth of Athena and the New Greek Age

105, 106. Sculpture photos courtesy of the British Museum, London.

107. Helios red figure depiction scanned from page 28 of *Titans and Olympians*, a Time-Life book edited by Tony Allan.

108. Helios, Attic red figure hydria drawing, Karlsruhe 259, photograph by Maria Daniels, from Furtwängler & Reichhold, pl. 30. Karlsruhe, Badisches Landesmuseum (Perseus Library).

108. Helios sculpture: photograph courtesy Museum of Fine Arts, Boston (Perseus Library).

Chapter Twelve: Herakles—Nimrod Transplanted to Greek Soil

109. Photograph of Herakles east pediment sculpture courtesy of the Trustees of the British Museum, London.

111. Herakles feasting with Athena, Munich 2301, Munich Antikensammlunge. Photograph copyright Staatl. Antikensammlungen und Glyptothek, München (Perseus Library).

112. Apotheosis of Herakles, Attic red figure pelike, Munich 2360, Munich Antikensammlunge (Perseus Library).

113. Marriage of Herakles and Hebe, Attic red figure pyxis, Philadelphia

MS5462. University Museum, University of Pennsylania (Perseus Library).

114. Seal and tripod images scanned from T. H. Carpenter's *Art and Myth in Ancient Greece*, figures 174, 175.

115. Herakles attacking lion, Attic black figure, Tampa 86.54. Photograph by Maria Daniels, courtesy of the Tampa Museum of Art (Perseus Library).

117. Geryon and Atlas metopes, Temple of Zeus. Photographs by Maria Daniels, courtesy of the Greek Ministry of Culture, Olympia. Geryon Metope drawing © C. H. Smith 1990 (Perseus Library).

118. Enthroned Zeus painting © M. Larrinaga from http://ce.eng.usf.edu/pharos/wonders/zeus.html. Copyright © 1995, 1999, 2001 by Alaa K. Ashmawy.

119. Herakles and Nereus shield band panel scanned from figure 87 in T. H. Carpenter's *Art and Myth in Ancient Greece*.

119. Herakles and Nereus red figure hydria, London E 162. Photograph courtesy of the Trustees of the British Museum, London (Perseus Library).

120. Drawings of three east metopes under the east pediment scanned from page 235 of John Boardman's *The Parthenon and Its Sculpture*.

122. Herakles, Hermes, and Alkyoneus, Attic red figure, Munich 2590. Munich Antikensammlunge. Photograph copyright Stattl. Antikensammlungen und Glyptothek, München (Perseus Library).

122. Athena kills a Giant image, courtesy Hellenic Ministry of Culture, Akropolis Museum Web site.

123. Dionysos killing Giant Attic red figure, Berlin F 2321. Berlin, Antikenmuseen. Photograph by Maria Daniels, courtesy of the Staatliche Museen zu Berlin, Preußischer Kulturbesitz: Antikensammlung (Perseus Library).

Chapter Thirteen: The Three Fates—Death Turned Back by the Immortal Athena

125, 127. Sculpture photographs courtesy of the British Museum, London.

Chapter Fourteen: Nike Amplifies the Victory of Zeus and Athena

130. Zeus and Nike, Attic red figure, Louvre S 1677. Photograph by Maria Daniels, courtesy of the Musée du Louvre, Paris (Perseus Library).

131. Athena Parthenos, Attic red figure, Berlin V. I. 3199. Photograph by Maria Daniels, courtesy of the Staatliche Museen zu Berlin, Preußischer Kulturbesitz: Antikensammlung (Perseus Library).

133. Birth of Athena with Nike, Attic black figure, Philadelphia MS3441. Photograph by Maria Daniels, courtesy of The University Museum, Philadelphia (Perseus Library).

134. Photo of Nike of Samothrace, courtesy Musée du Louvre, Paris.

Chapter Fifteen: A Summary of the East Pediment

136. Head of Hera scanned from page 64 of *The Horizon Book of Ancient Greece*.

136. Head of Zeus, Munich GL 294. Photograph by Maria Daniels, copyright Staatl. Antikensammlungen und Glyptothek, München (Perseus Library).

138. Head of Athena. Photograph by Maria Daniels, copyright Staatl. Antikensammlungen und Glyptothek, München (Perseus Library).

139. Hephaistos Bronze scanned from page 74 of *The Horizon Book of Ancient Greece*.

Bibliography

Allan, Tony, ed., 1997. *Titans and Olympians: Greek and Roman Myth.* Time-Life Books BV, Amsterdam.

Ashmole, Bernard and Yalouris, Nicholas, 1967. *Olympia: the Sculptures of the Temple of Zeus.* Phaidon Press, London.

Ashmole, Bernard, 1972. *Architect and Sculpture in Classical Greece* (The Wrightsman Lectures), New York University Press.

Baring, Anne, and Cashford, Jules. 1991. *The Myth of the Goddess, Evolution of an Image.* Viking Arkana, Penguin Books Ltd., London.

Biers, William R., Second Ed. 1996. *The Archaeology of Greece.* Cornell University Press, Ithaca and London.

Boardman, John; Dörig, José; Fuchs, Werner; and Hirmer, Max, 1967. *The Art and Architecture of Ancient Greece.* Thames and Hudson, London.

Boardman, John, 1985. *Greek Sculpture: the Classical Period, a Handbook.* Thames and Hudson, Ltd., London.

Boardman, John, 1985. *The Parthenon and Its Sculpture.* University of Texas Press, Austin.

Boardman, John, 1993. *Athenian Black Figure Vases: a Handbook.* Thames and Hudson, Ltd., London.

Boardman, John; Griffin, Jasper; and Murray, Oswyn, 1988. *Greece and the Hellenistic World.* Oxford University Press, Oxford, England.

Boardman, John, 1997. *Athenian Red Figure Vases: the Classical Period, a Handbook.* Thames and Hudson, Ltd., London.

Boardman, John, 1996. *Greek Art.* Thames and Hudson, Ltd., London.

Boardman, John, 2000. *Athenian Red Figure Vases: The Archaic Period, a Handbook.* Thames and Hudson, Ltd., London.

Bothmer, Dietrich Von, 1957. *Amazons in Greek Art.* Oxford University Press, Oxford.

Bowra, C. M. and the Editors of Time-Life Books, 1965. *Classical Greece.* Time-Life Books, Alexandria, Virginia.

Burckhardt, Jacob, 1998. *The Greeks and Greek Civilization.* St. Martin's Press, New York.

Burkert, Walter, 1983. *Homo Necans.* University of California Press, Berkeley and Los Angeles.

Camp, John M. 1986. *The Athenian Agora: Excavations in the Heart of Classical Athens.* Thames and Hudson, London.

Campbell, Joseph, 1964. *The Masks of God: Occidental Mythology.* The Viking Press, Inc., New York.

Carpenter, T. H., 1991. *Art and Myth in Ancient Greece.* Thames and Hudson, Ltd., London.

Castriota, David. 1992. *Myth, Ethos, and Actuality—Official Art in Fifth-Century B.C. Athens.* The University of Wisconsin Press.

Charbonneaux, Jean, 1972. *Classical Greek Art* (480-330 B.C.). George Braziller, New York.

Connolly, Peter and Dodge, Hazel 1998. *The Ancient City: Life in Classical Athens and Rome*. Oxford University Press, Oxford and New York.

Cook, B. F., 1997. *The Elgin Marbles*. British Museum Press, London.

Crane, Gregory, ed., 2000, Compact Disc: Perseus 2.0 Platform Independent Version. *Interactive Sources and Studies on Ancient Greece*. Yale University Press, New Haven and London.

Dersin, Denise, ed., *What Life Was Like at the Dawn of Democracy*. Time-Life Books, Virginia.

Donohue, A. A. 1988. *Xoana and the Origins of Greek Sculpture*. Scholars Press, Atlanta, Georgia.

Durando, Furio Stewart, 1997. *Ancient Greece: The Dawn of the Western World*. Tabori & Chang, New York.

Durant, Will, 1939. *The Life of Greece*. Simon and Schuster, New York.

Geldard, Richard G. 1989. *The Traveler's Key to Ancient Greece*. Alfred A. Knopf, New York.

Goldhill, Simon and Osborne, Robin, eds. 1994. *Art and Text in Ancient Greek Culture*. Cambridge University Press.

Grant, Michael, 1987. *The Rise of the Greeks*. Charles Scribner's Sons, New York.

Green, Peter, 1978. *The Parthenon*. Newsweek, New York.

Green, Peter, 1995. *Ancient Greece: A Concise History*. Thames and Hudson, Ltd., London.

Grene, David and Lattimore, Richard, eds., 1955. *The Complete Greek Tragedies, Volume III Euripides*, The University of Chicago Press, Chicago.

Hale, W. H., ed. 1965. *The Horizon Book of Ancient Greece*. American Heritage Publishing Co., Inc., New York.

Harrison, Jane Ellen, 1962. *Epilegomena to the Study of Greek Religion and Themis*. University Books, New Hyde Park, New York.

Harrison, Jane Ellen, 1991. *Prolegomena to the Study of Greek Religion*. Princeton University Press, Princeton, New Jersey.

Hislop, Alexander, 1916. *The Two Babylons*, Loizeaux Brothers, Neptune, New Jersey.

Hornblower, Simon and Spawforth, Anthony, eds., 1998. *The Oxford Companion to Classical Civilization*. Oxford University Press, Oxford and New York.

Jeppesen, Kristian K., 1982. "Evidence for the Restoration of the East Pediment Reconsidered in the Light of Recent Achievements." *Parthenon Kongress*, Basel.

Kerenyi, C., 1951. *The Gods of the Greeks*. Thames and Hudson, New York.

Kerenyi, C., 1963. *Prometheus: Archtypal Image of Human Existence*. Pantheon Books, Random House, Inc. New York.

Kerenyi, C., 1976. *Dionysos*. Bollinger Series 2, Princeton University Press, Princeton, New Jersey.

Kerenyi, C., 1975. *Zeus and Hera*. Princeton University Press, Princeton, New Jersey.

Kokkinou, Sophia, 1989. *Greek Mythology*. Sophia Kokkinou, Athens.

Lagerlöf, Margaretha Rossholm, 2000. *The Sculptures of the Parthenon: Aesthetics and Interpretation*. Yale University Press, New Haven and London.

Lefkowitz, Mary R., 1990. *Women in Greek Myth*. The Johns Hopkins University Press, Baltimore.

Morford, Mark P. O. and Lenardon, Robert J. 1971. *Classical Mythology*. David McKay Company, Inc., New York.

Neils, Jenifer., Ed. 1996. *Panathenaia & Parthenon*. The University of Wisconsin Press.

Palagia, Olga, 1993. *The Pediments of the Parthenon*. E. J. Brill, New York.

Parada, Carlos, 1993. *Genealogical Guide to Greek Mythology*. Paul Astroms Forlag, Jonsered, Sweden.

Parke, H. W. 1977. *Festivals of the Athenians*. Cornell University Press, Ithaca, New York.

Parker, Robert 1996. *Athenian Religion: A History*. Clarendon Press, Oxford, England.

Pinsent, John, 1969. *Greek Mythology*. Peter Bedrick Books, New York.

Pollit, J. J., 1972. *Art and Experience in Classical Greece*. Cambridge University Press, London.

Reeder, Ellen D., ed. 1995. *Pandora: Women in Classical Greece*. Princeton University Press, Princeton, New Jersey.

Rodenbeck, Christina, ed., 1998. *Triumph of the Hero: Greek and Roman Myth*. Time-Life Books BV, Amsterdam.

Rodocanachi, C. P., 1951. *Athens and the Greek Miracle*. The Beacon Press, Boston.

Schmidt, Evamaria. 1965. *The Great Altar at Pergamon*. Boston Book and Art Shop, Inc., Boston.

Schefold, Karl, 1967. *The Art of Classical Greece*. Greystone Press, New York.

Smith, R. R. R., 1991. *Hellenistic Sculpture*. Thames and Hudson, Ltd., London.

Spivey, Nigel, 1997. *Understanding Greek Sculpture*. Thames and Hudson, Ltd., London.

Stewart, J. A., 1970 (Reprint from 1905). *The Myths of Plato*. Barnes and Noble, Inc.

Stokstad, Marilyn, 1995. *Art History*. Harry N. Abrams, Inc., New York.

Stone, I. F., 1988. *The Trial of Socrates*. Anchor Books, Doubleday, New York.

Toorn, Karel van der and Becking, Bob and Horst, Pieter W. van der, eds. 1999. *Dictionary of Deities and Demons in the Bible*. William B. Eerdmans Publ. Company, Grand Rapids, MI / Cambridge, U. K.

Tripp, Edward 1970. *The Meridian Handbook of Classical Mythology*. New American Library, New York.

Tyrrell, Wm. Blake. 1984. *Amazons: A Study in Athenian Mythmaking*. The Johns Hopkins University Press, Baltimore and London.

Walker, Barbara G. 1983. *The Woman's Encyclopedia of Myths and Secrets*. Harper & Row Publishers, San Francisco.

Ward, Anne G. 1970. *The Quest for Theseus*. Praeger Publishers, Inc., New York.

West, John Anthony 1988. *Serpent in the Sky: The High Wisdom of Ancient Egypt*. Quest Books, Theological Publishing House, Wheaton, Illinois.

Wilde, Lyn Webster, 2000. *On the Trail of the Women Warriors: The Amazons in Myth and History*. Thomas Dunne Books, St. Martin's Press, New York.

From the Concordant Publishing Concern, Santa Clarita, California:

Concordant Literal New Testament with Keyword Concordance, sixth edition, 1976.

Concordant Commentary on the New Testament by A. E. Knoch, 1968.

Concordant Greek Text, fourth edition, 1975.

The Book of Genesis, Concordant Version of the Old Testament, 1957.

The Book of Isaiah, Concordant Version of the Old Testament, 1962.

Unsearchable Riches magazine, issues from 1933 to 2001.